ART OF COLORING

Disney

A Twisted Tale

100 IMAGES INSPIRED BY
THE BEST-SELLING SERIES

For information address Disney Editions, 1200 Grand Central Avenue, Glendale, California 91201.

Printed in the United States of America

First Paperback Edition, January 2024

1 3 5 7 9 10 8 6 4 2

ISBN 978-1-368-09927-1

FAC-067395-23320

Visit www.disneybooks.com

ART OF COLORING

Disney

A Twisted Tale

100 IMAGES INSPIRED BY THE BEST-SELLING SERIES

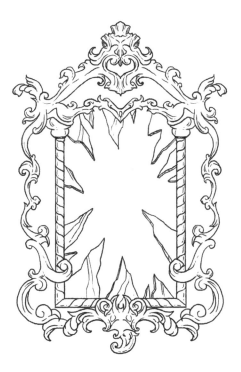

Illustrated by Abigail Larson

Disney

EDITIONS

Los Angeles · New York

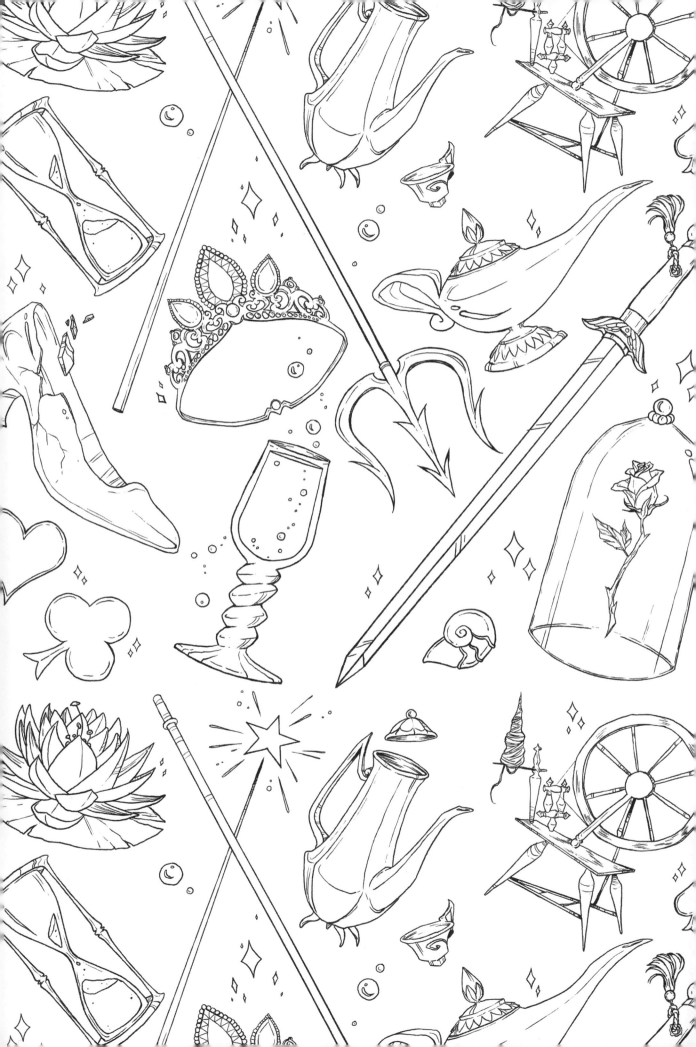

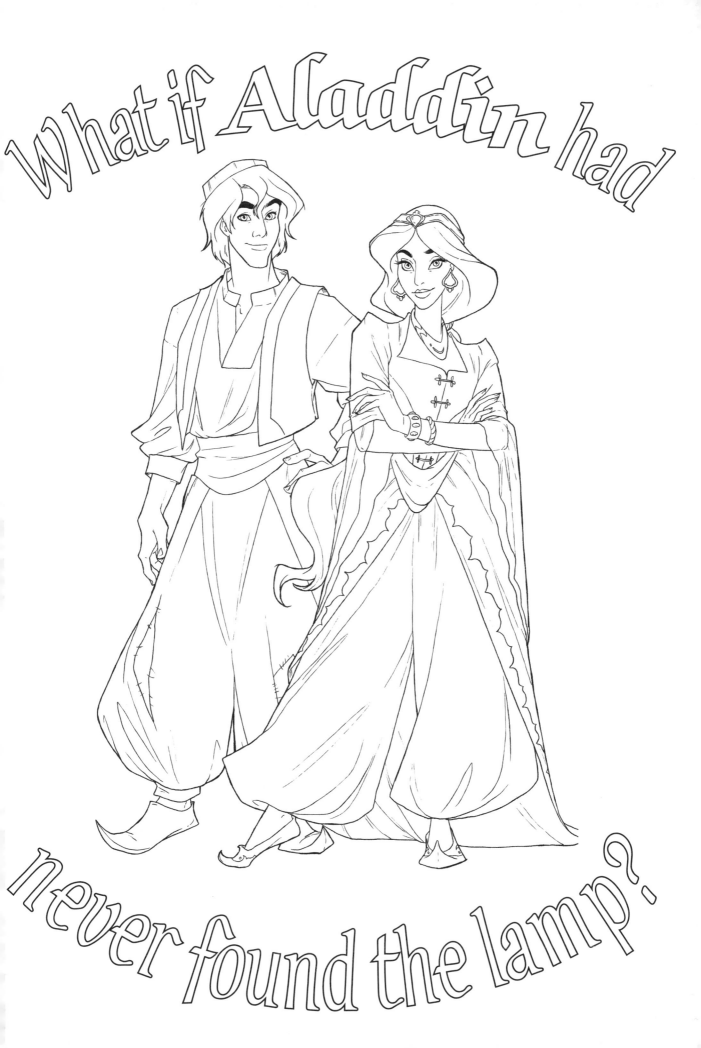

What if Aladdin had never found the lamp?

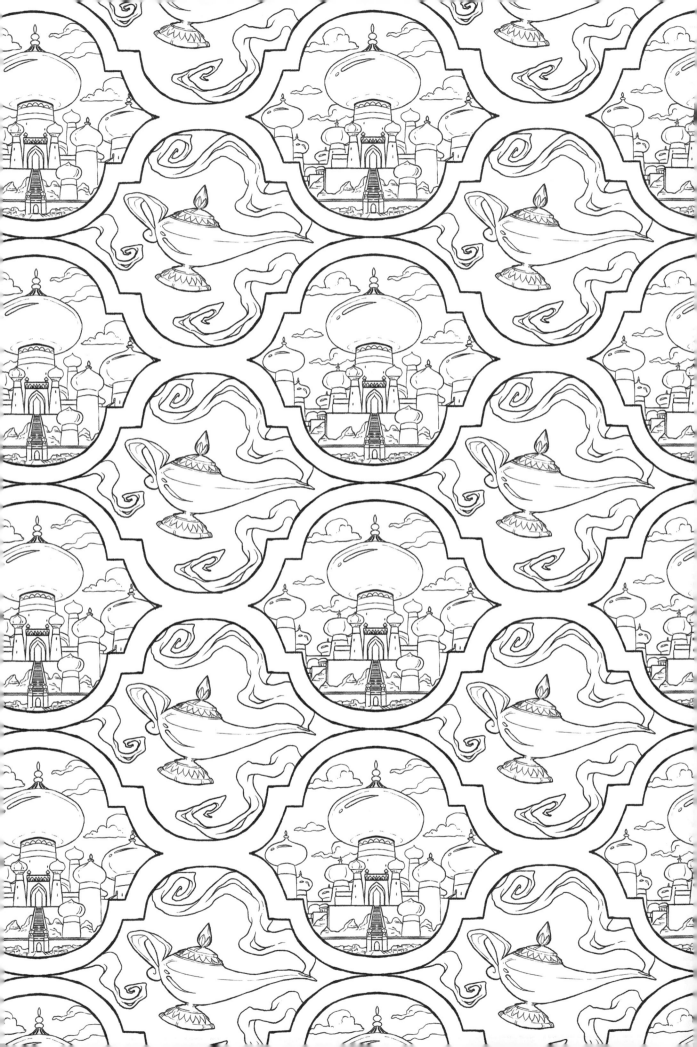

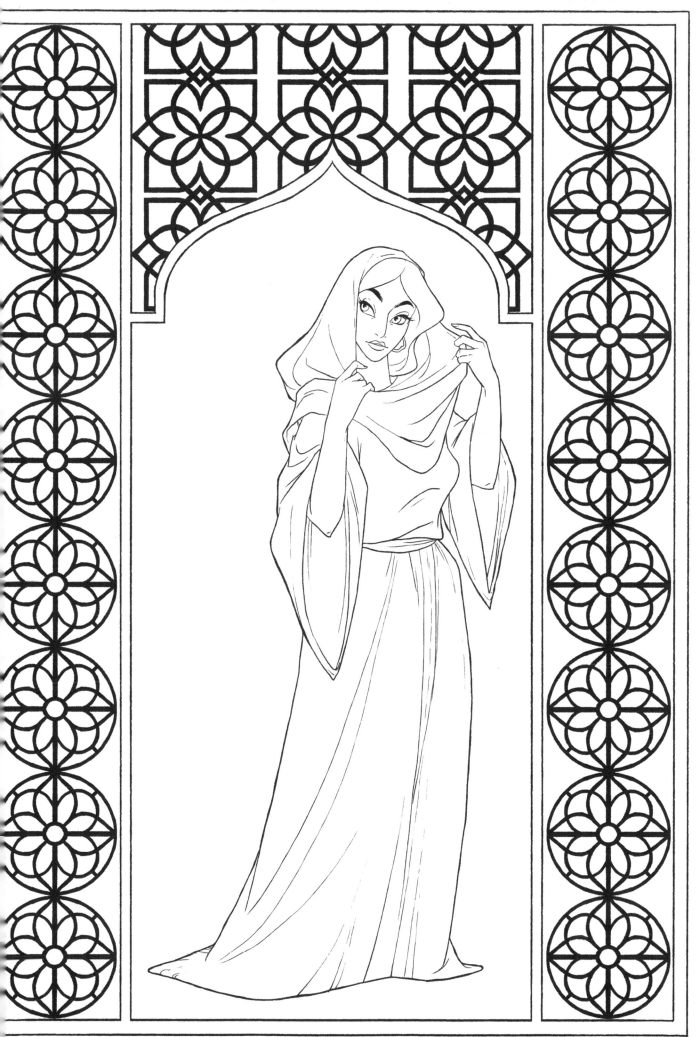

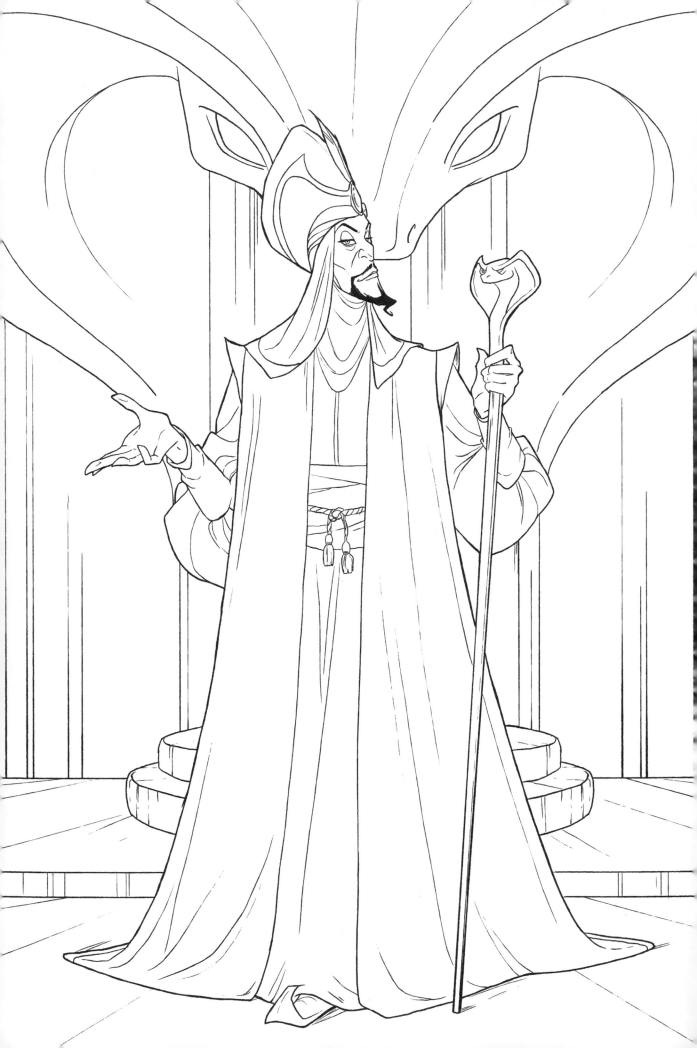

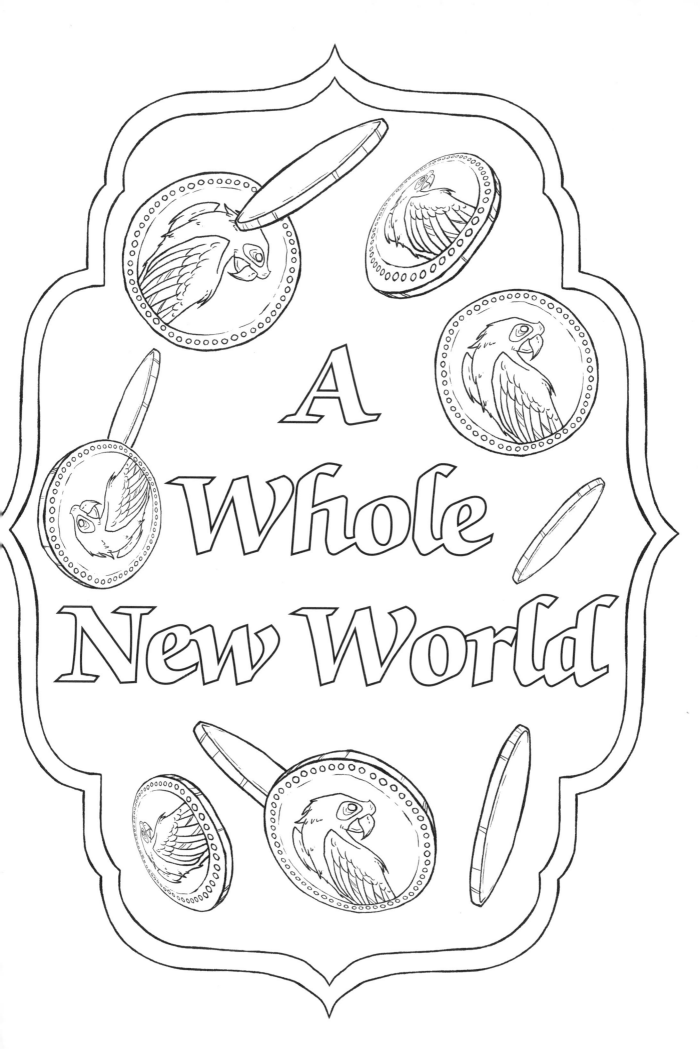

A Whole New World

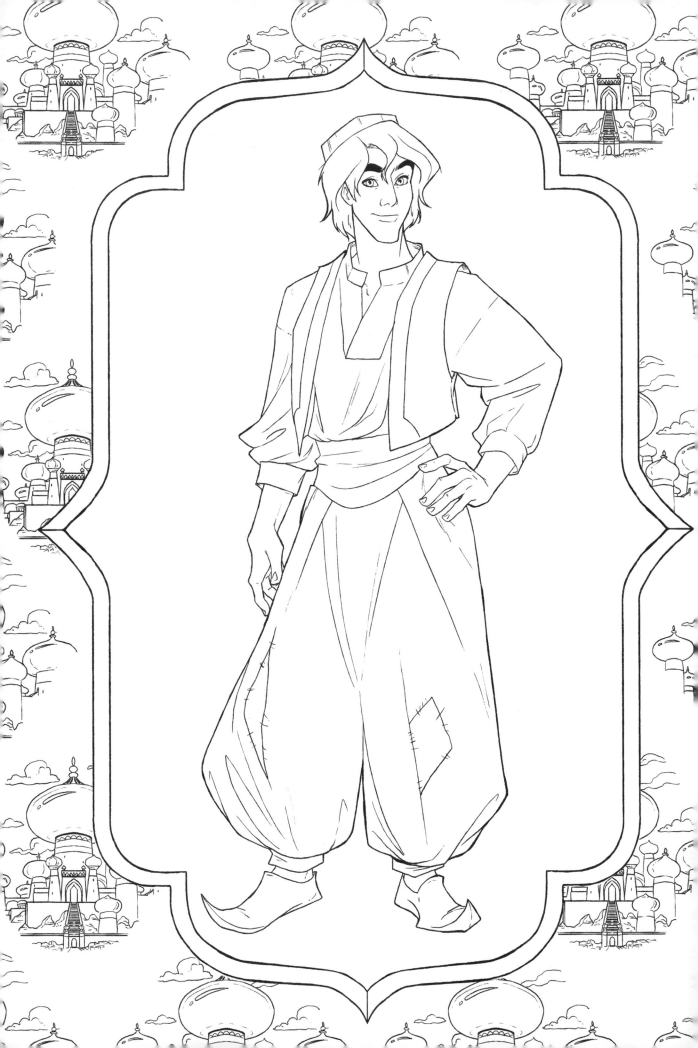

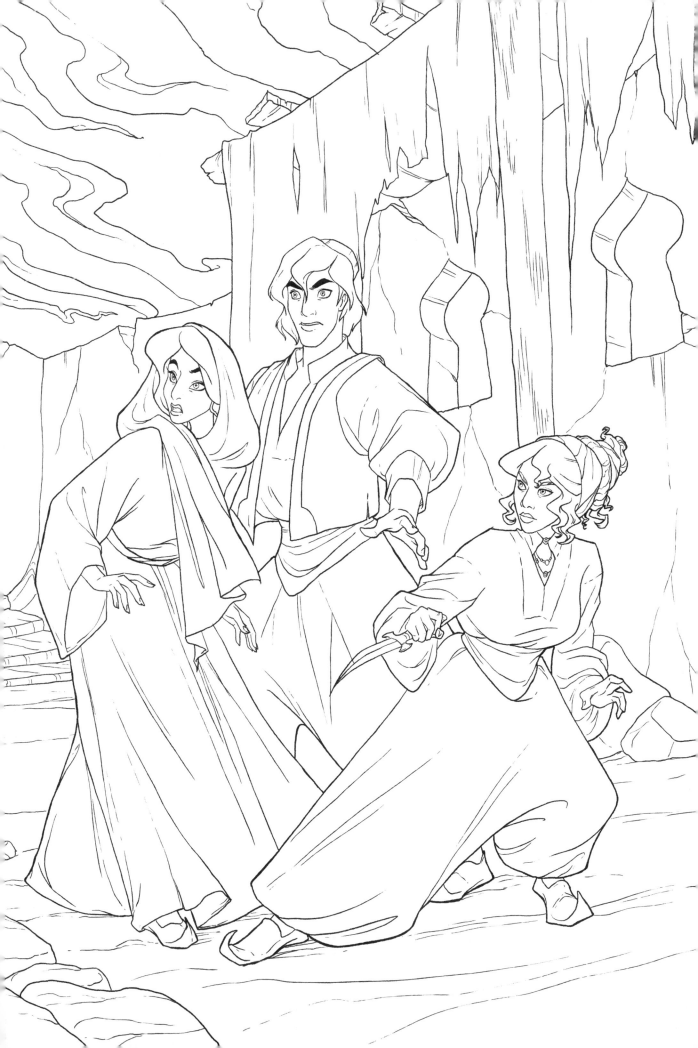

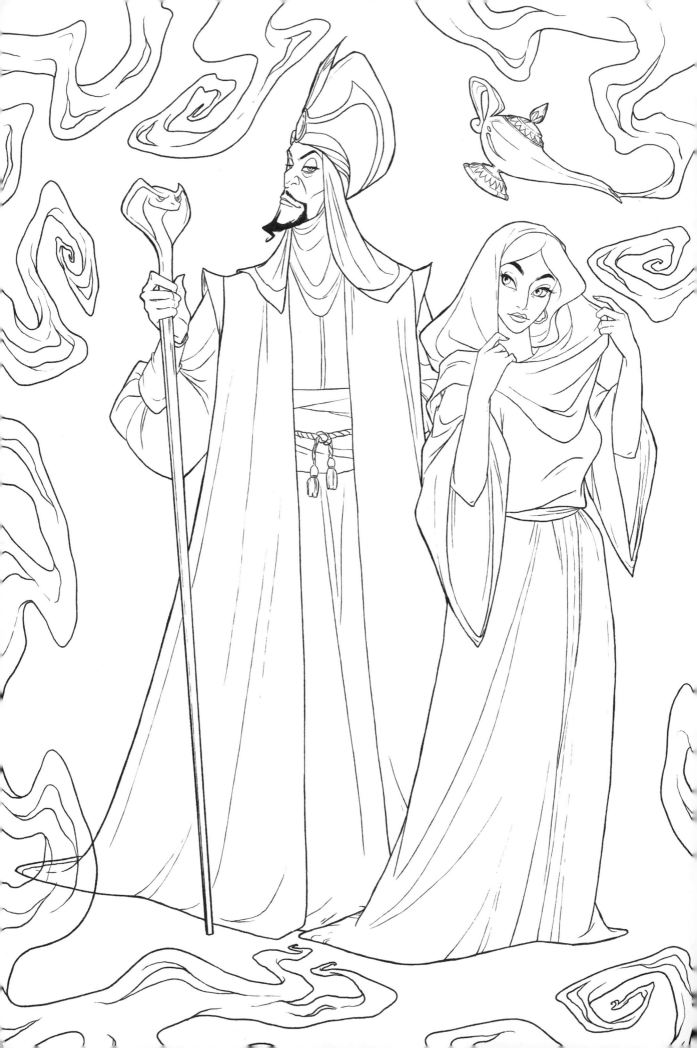

What if the sleeping beauty never woke up?

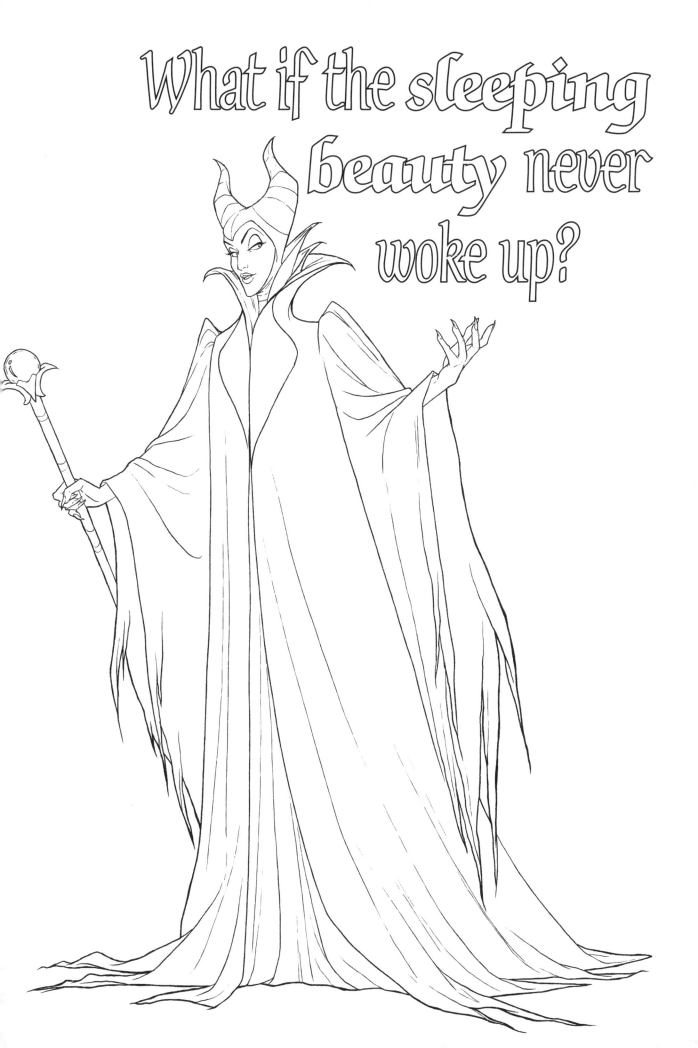

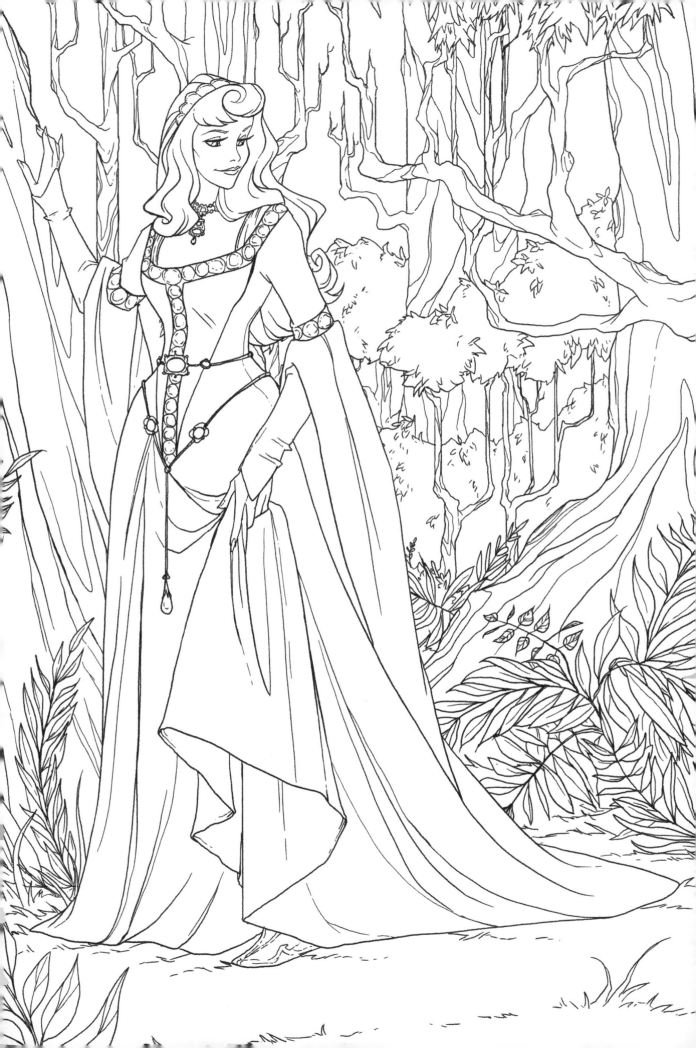

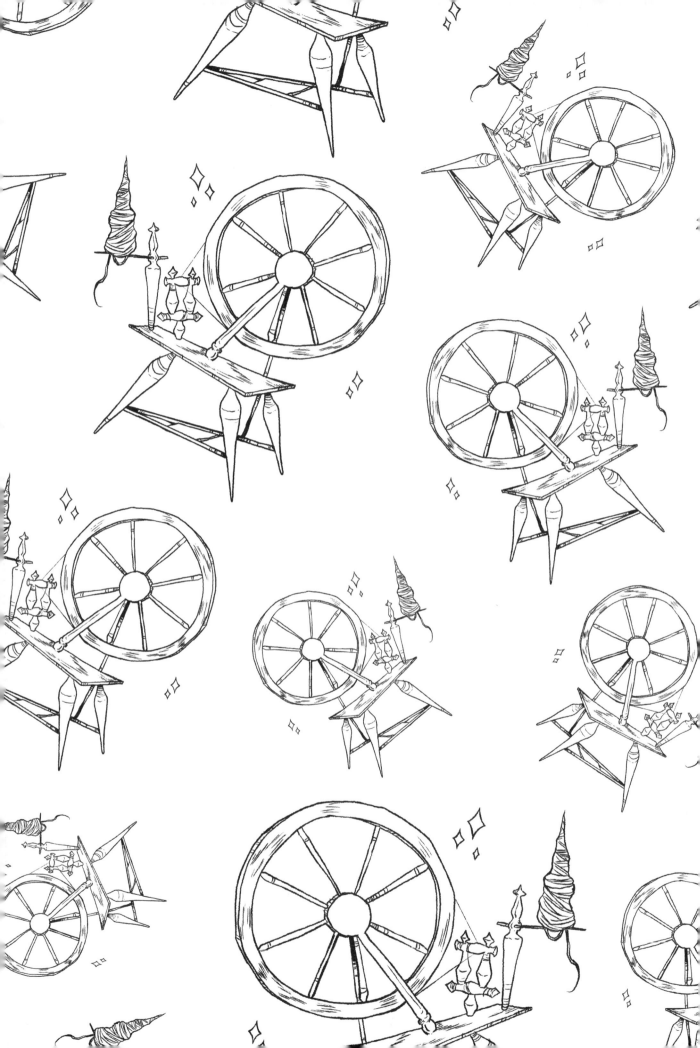

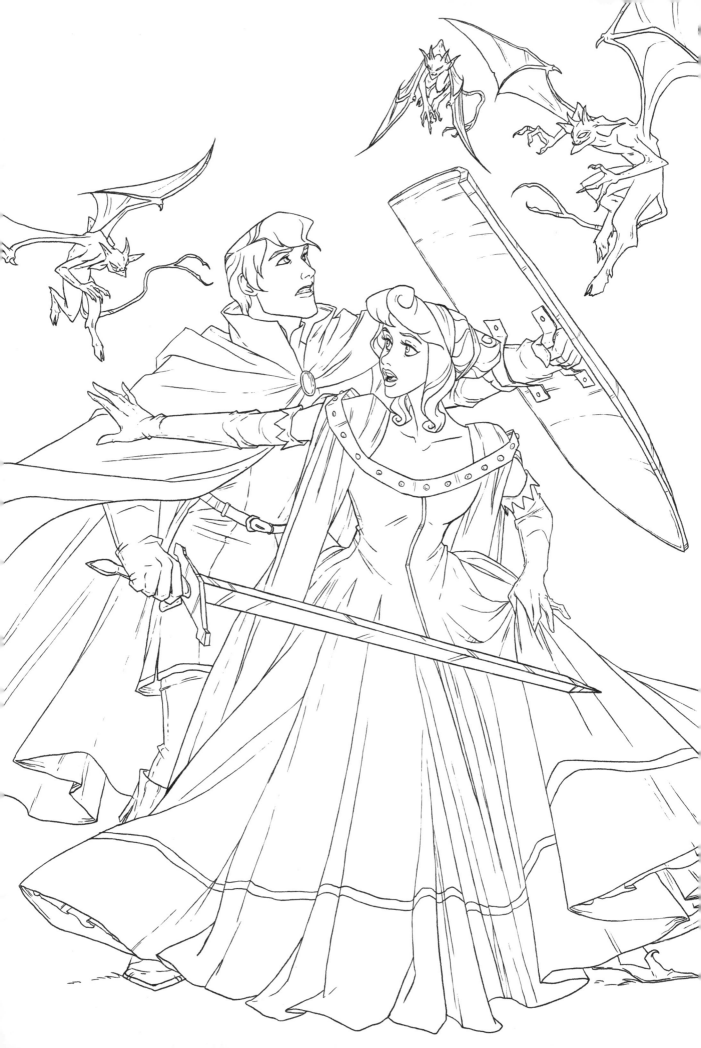

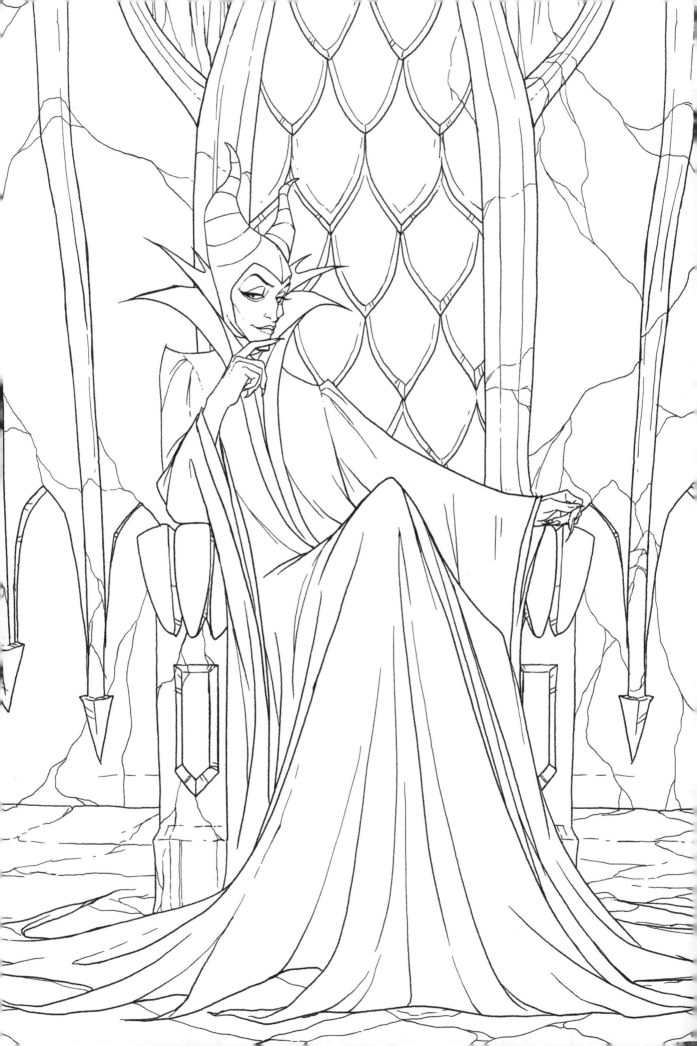

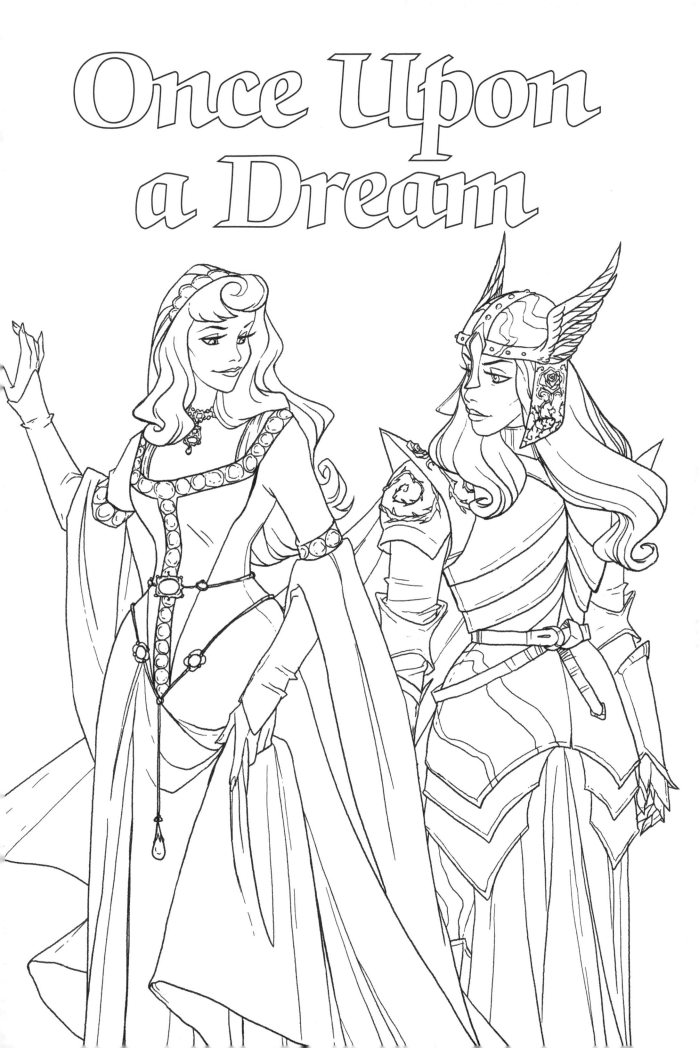

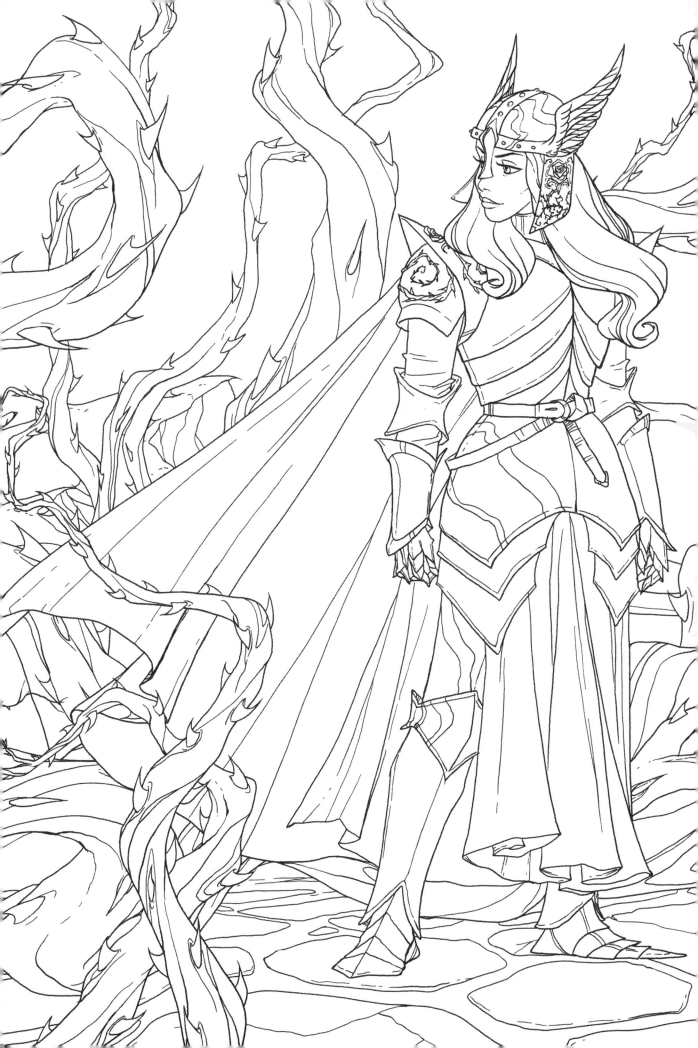

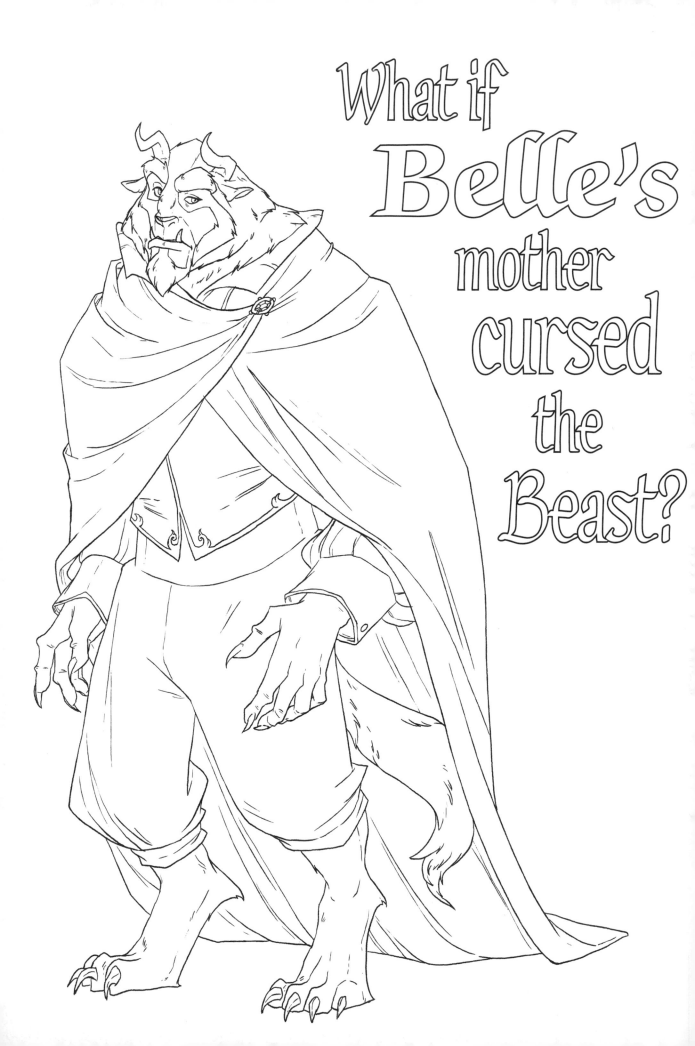

What if **Belle's** mother cursed the Beast?

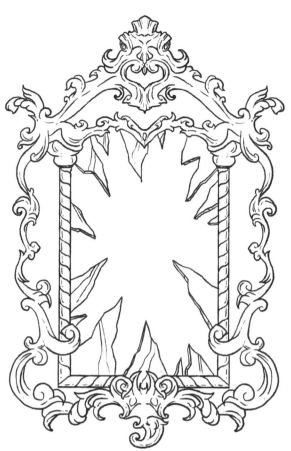
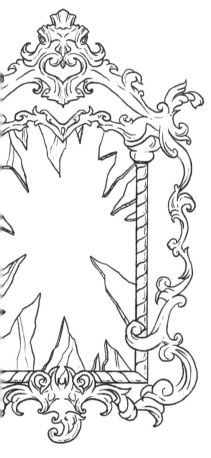
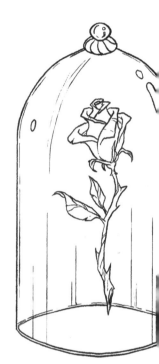
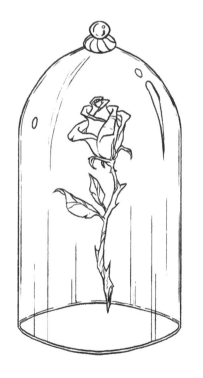
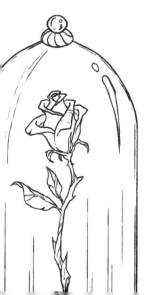

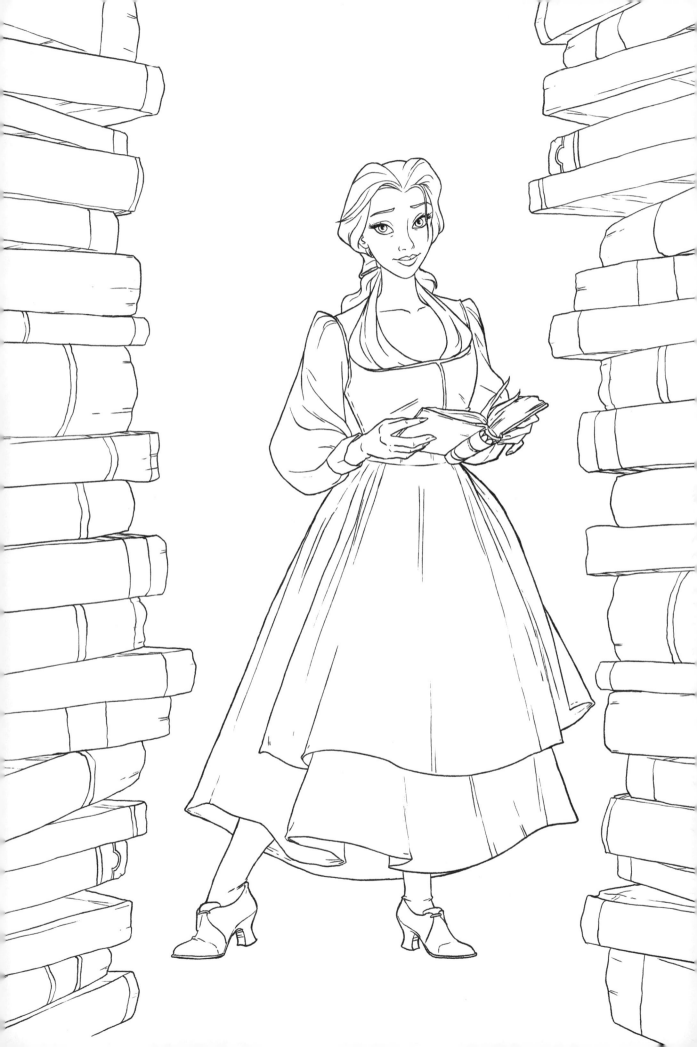

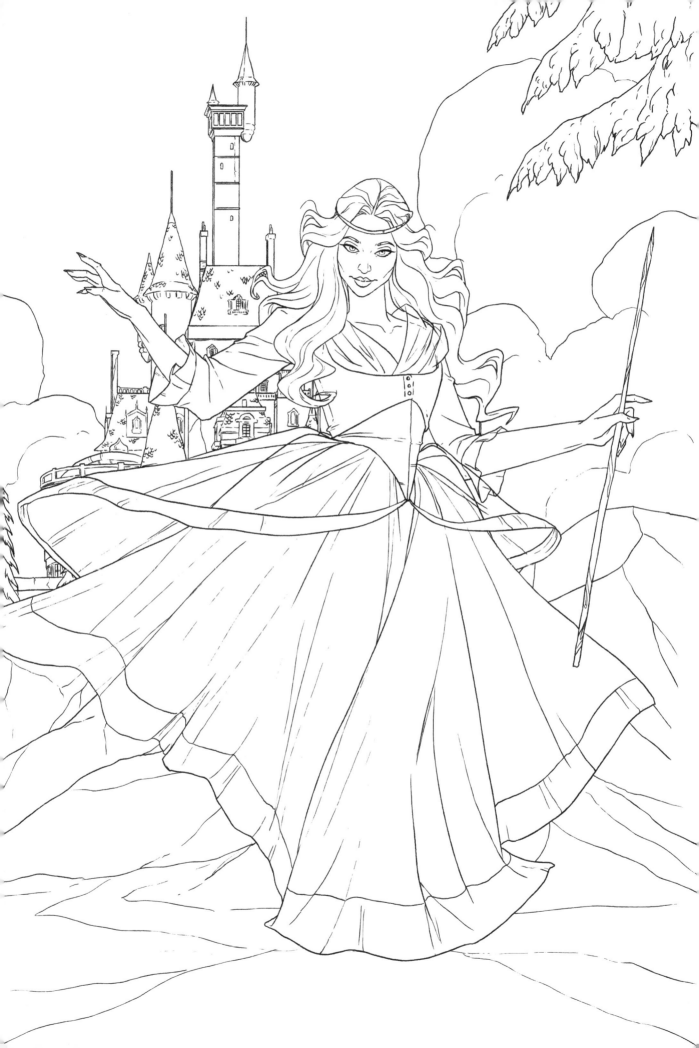

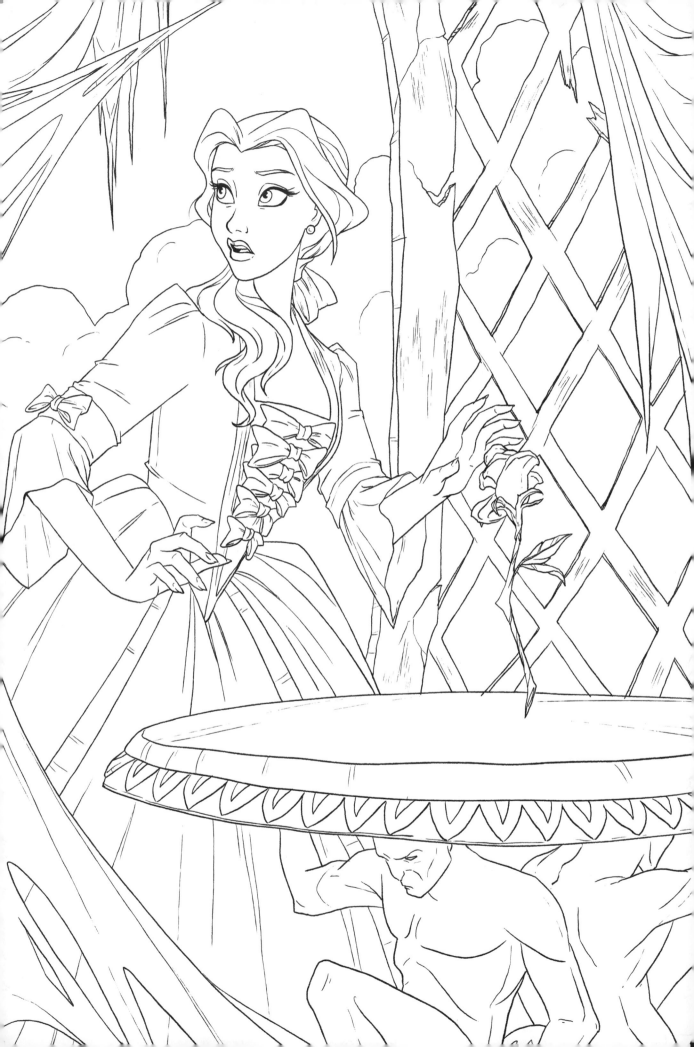

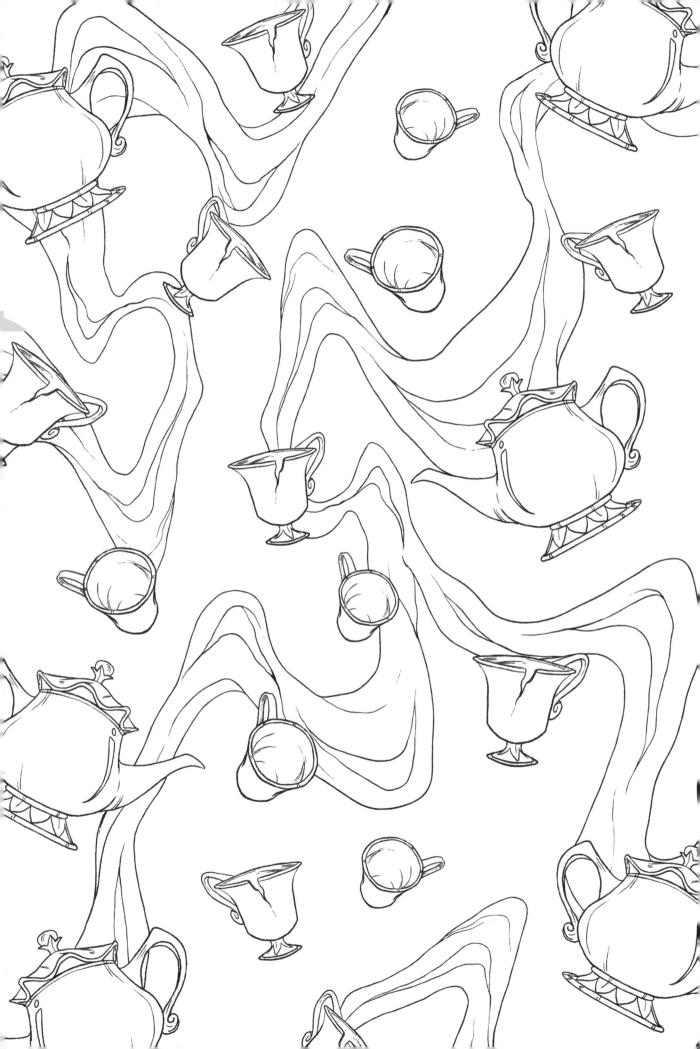

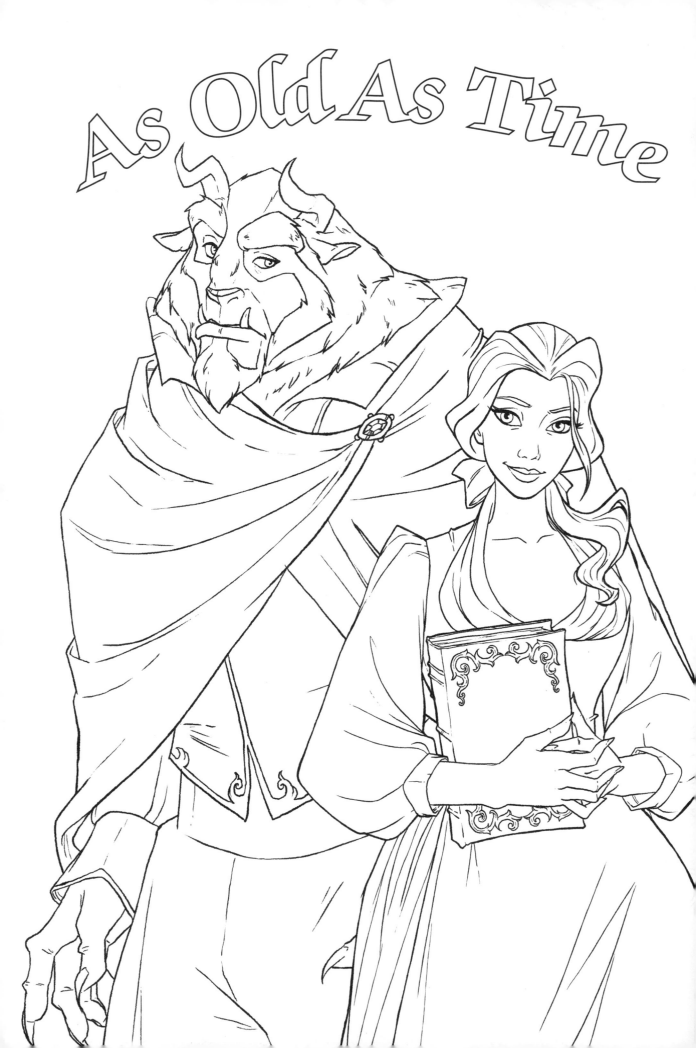

As Old As Time

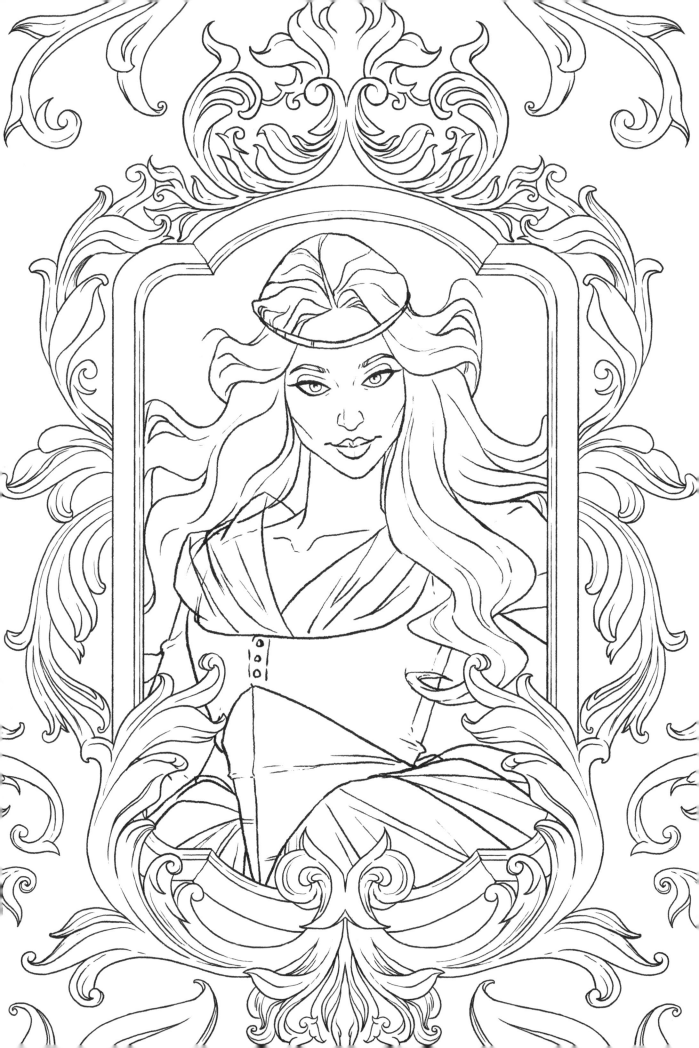

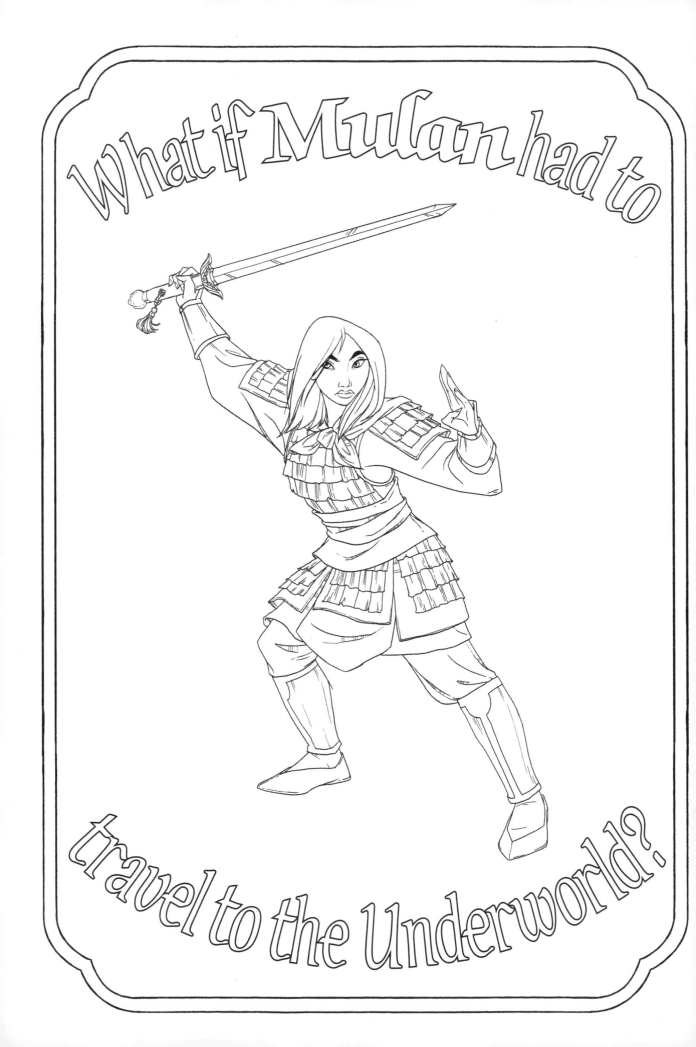

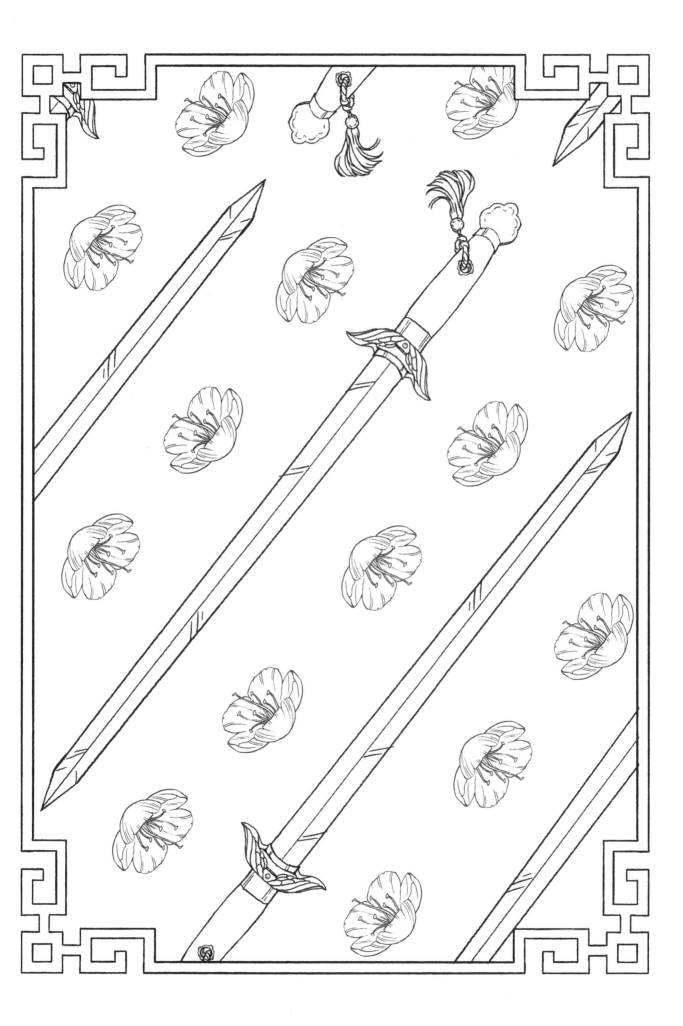

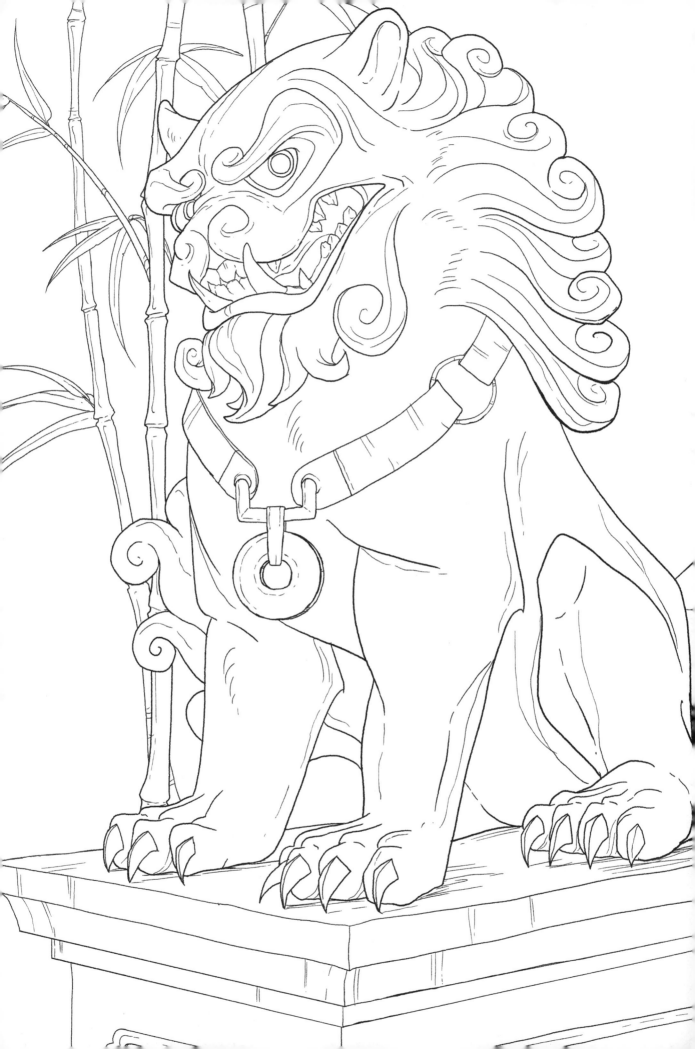

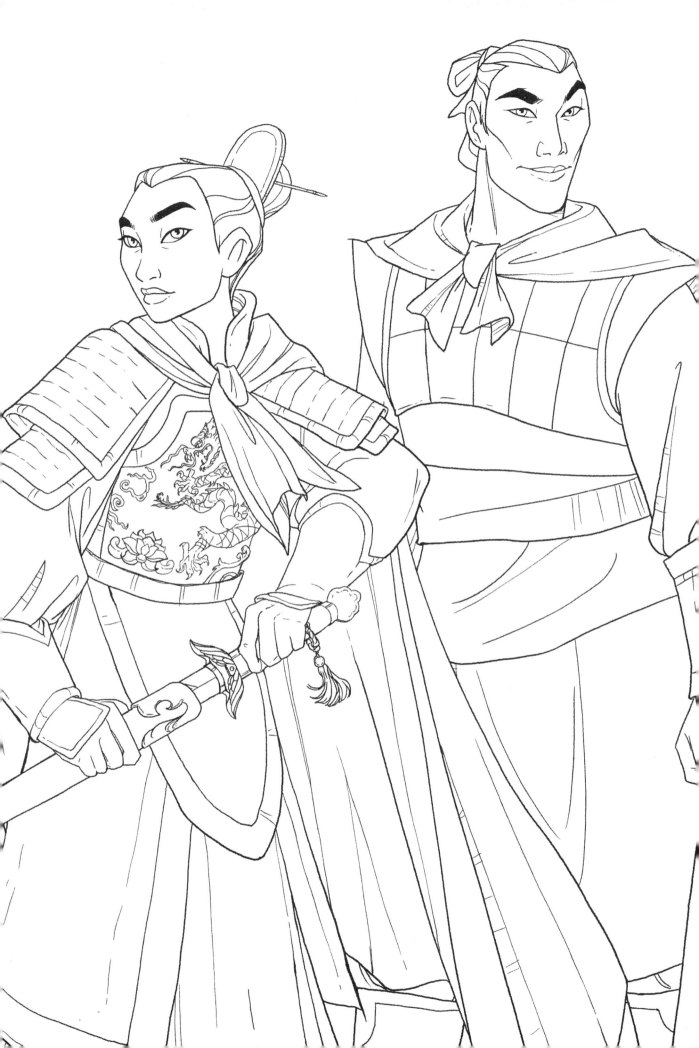

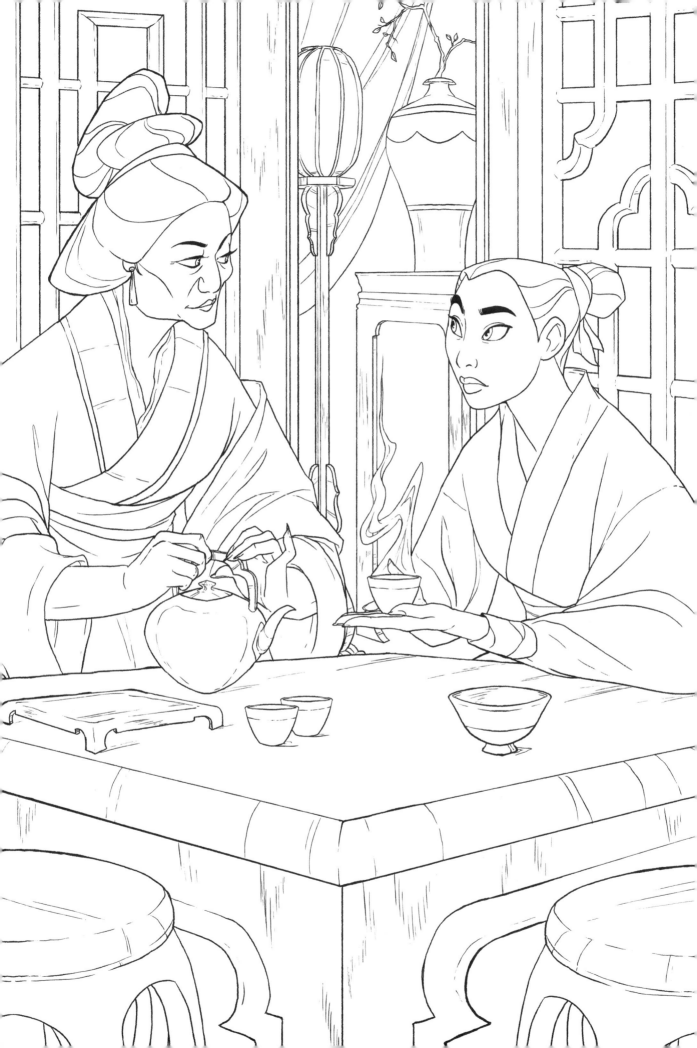

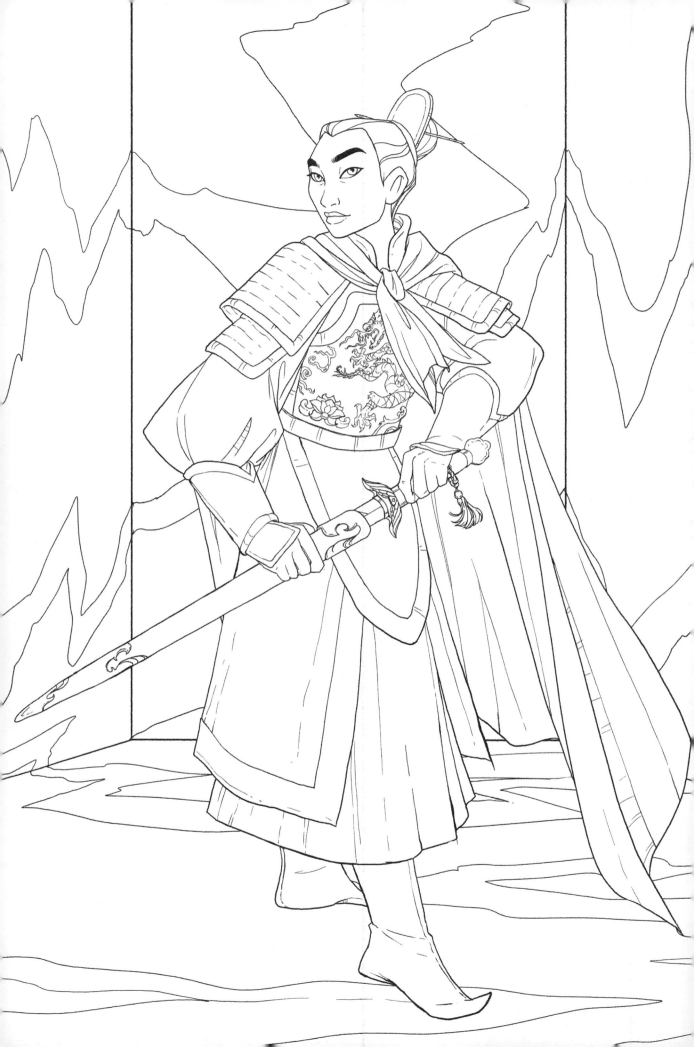

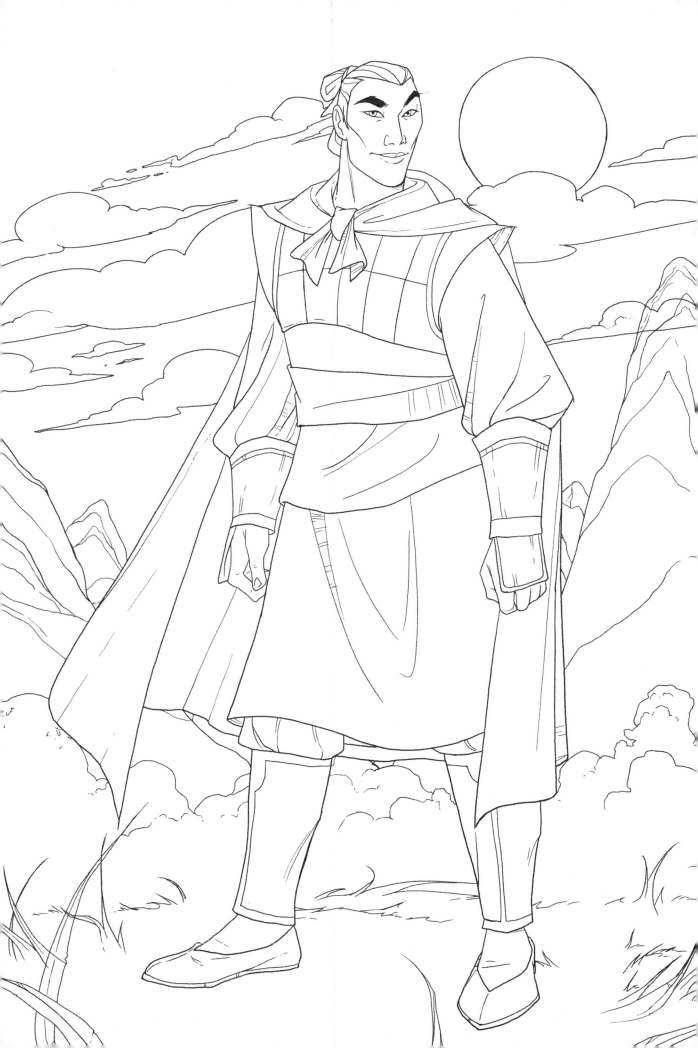

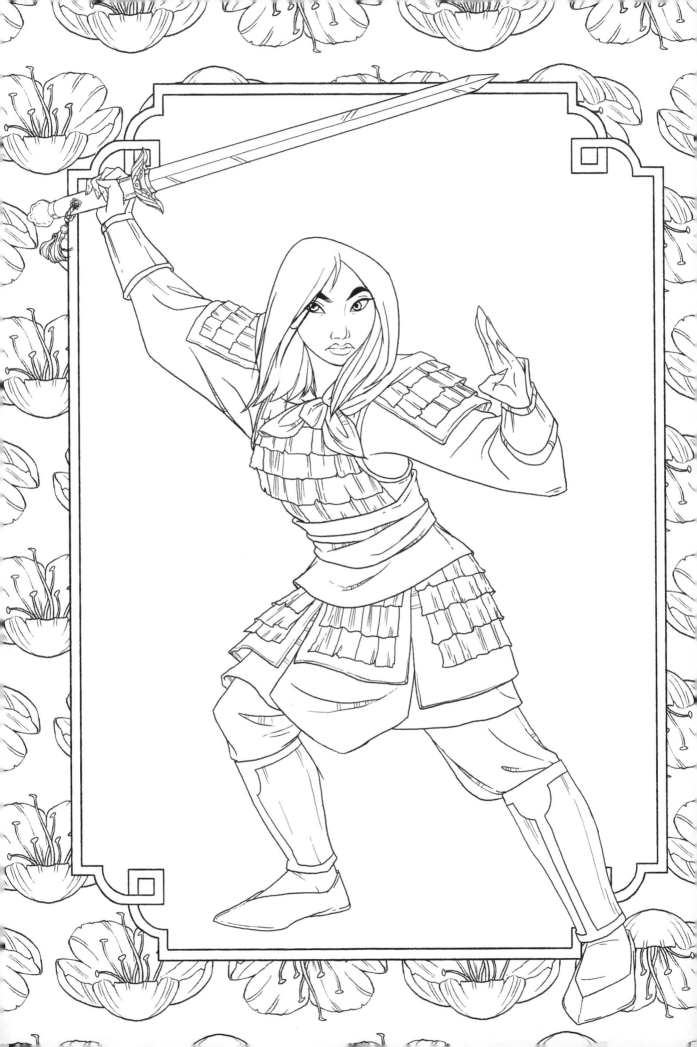

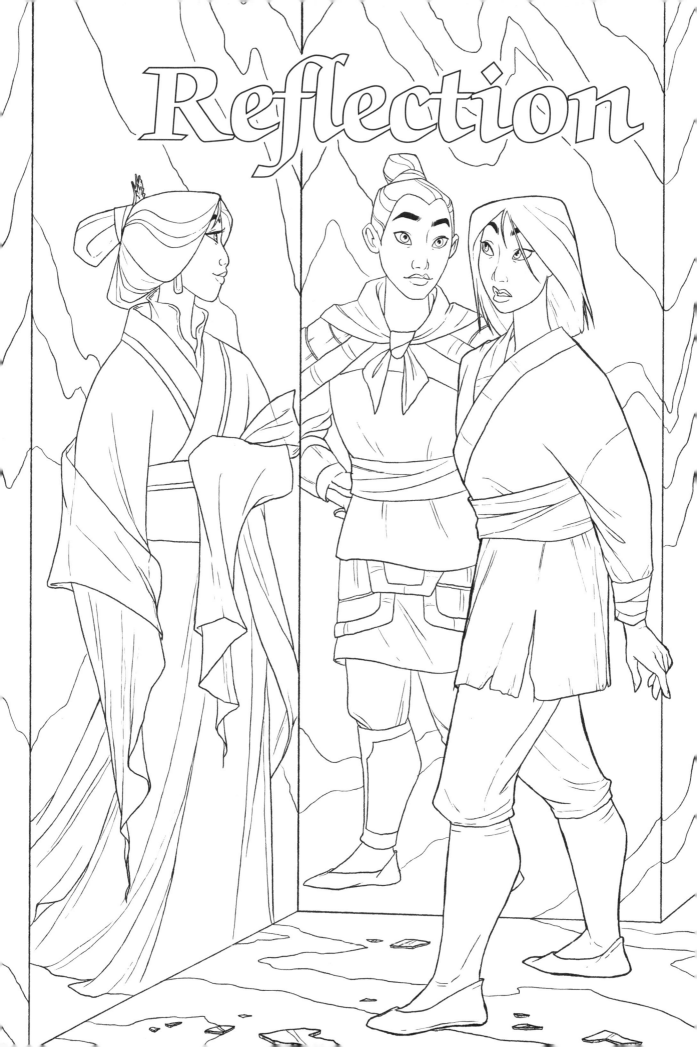

What if **Ariel** had never defeated Ursula?

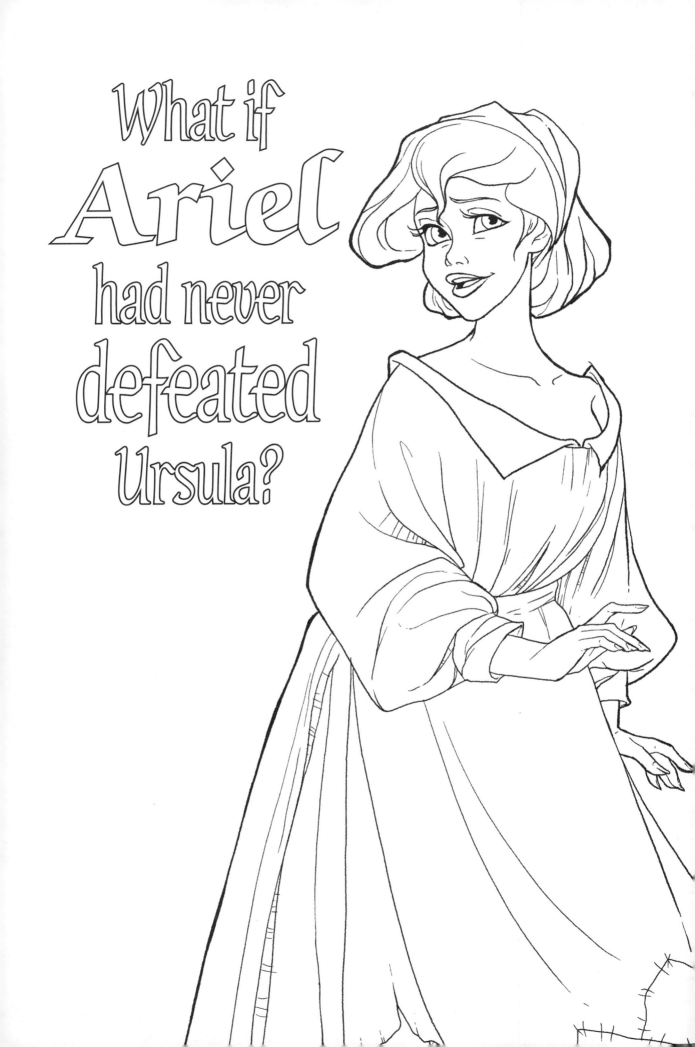

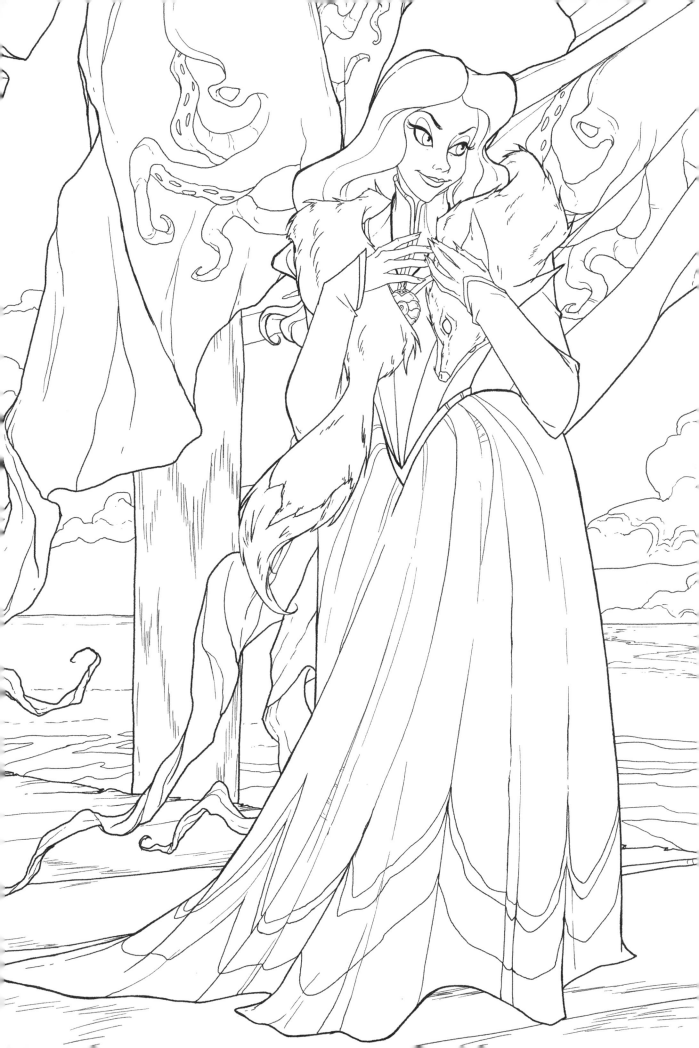

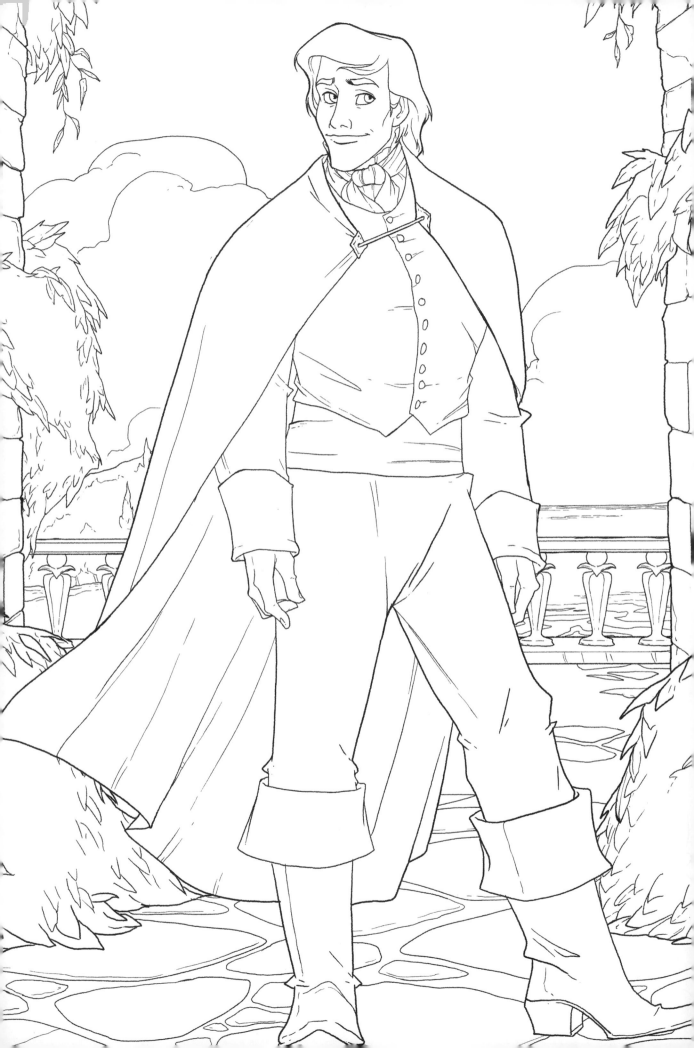

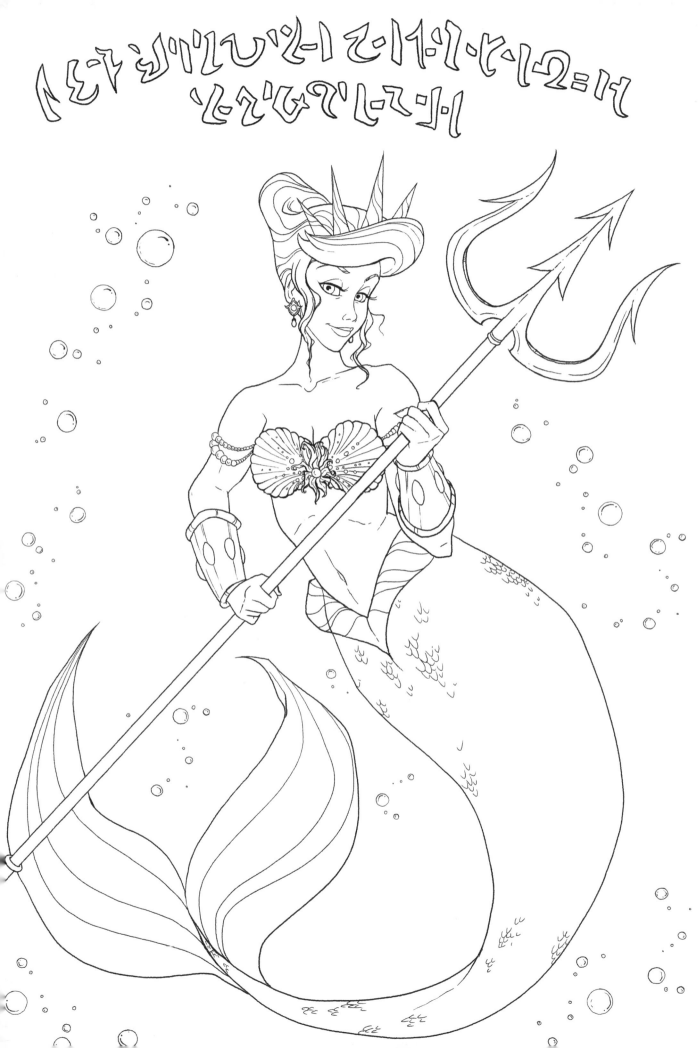

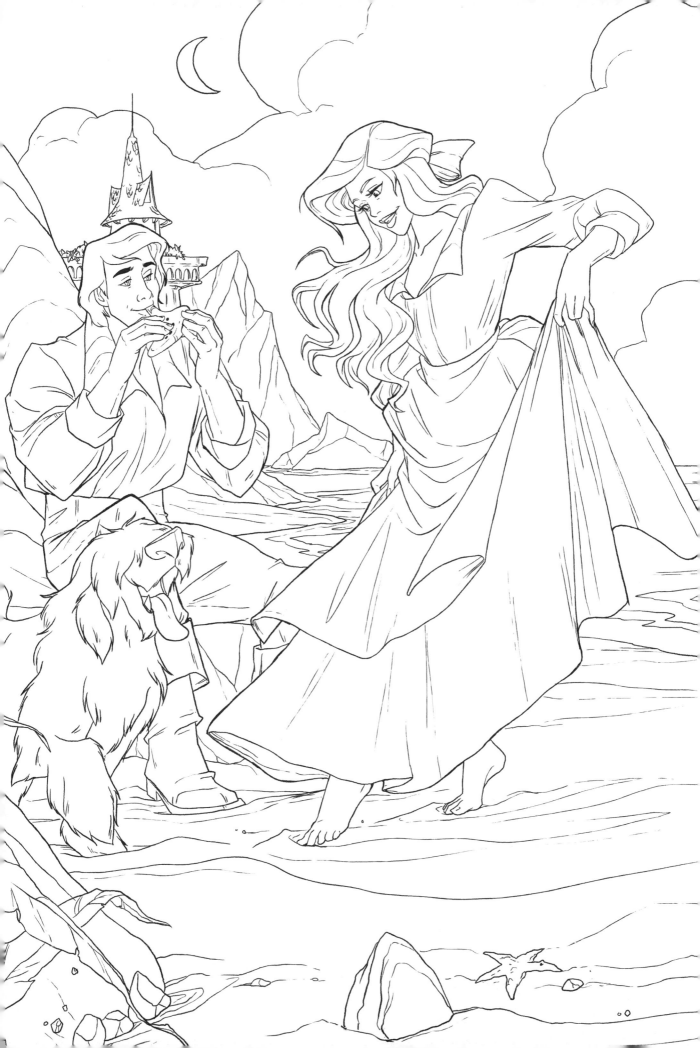

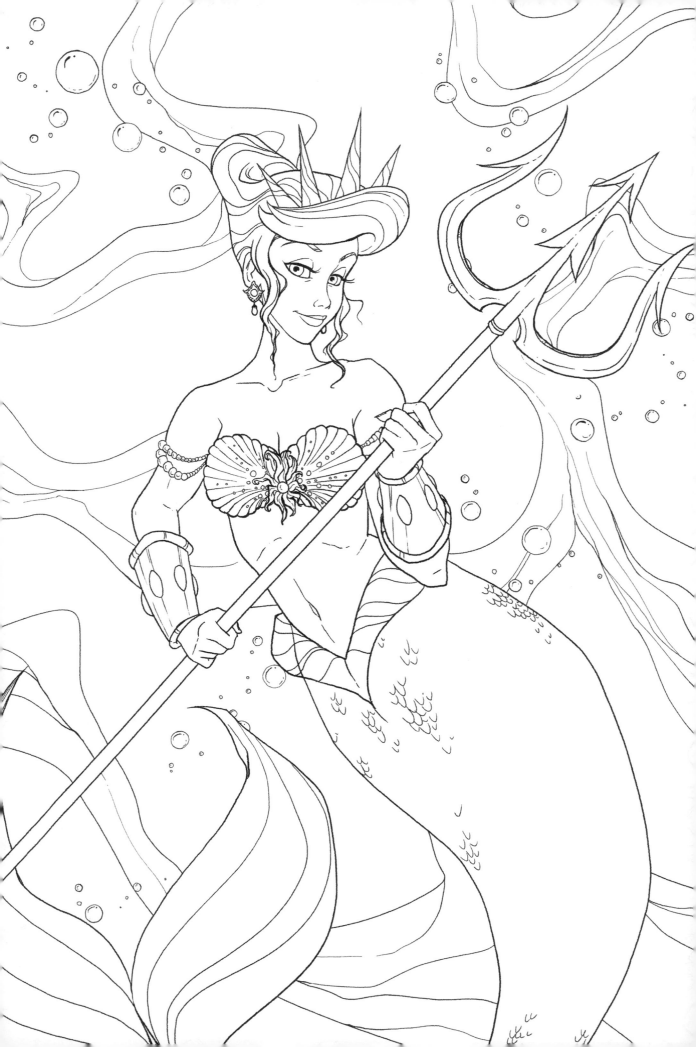

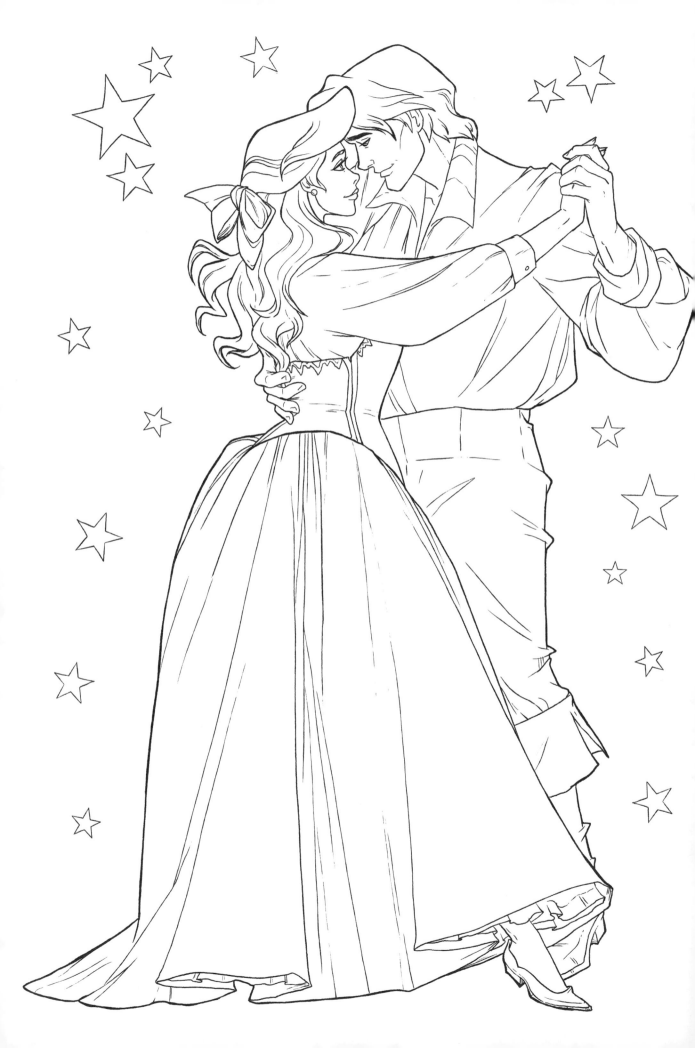

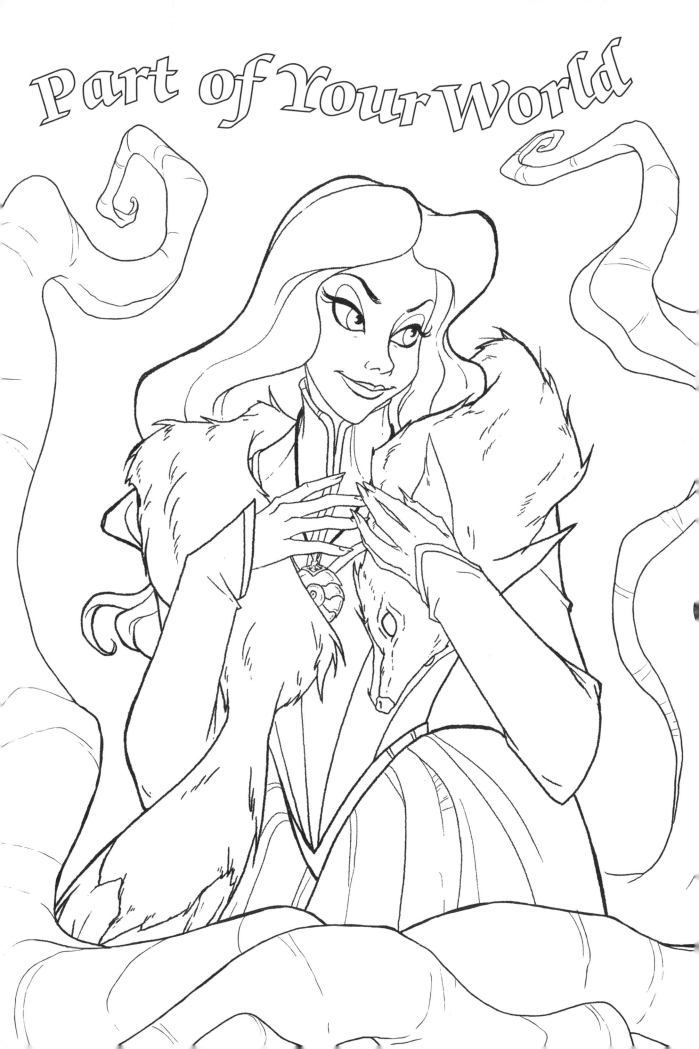

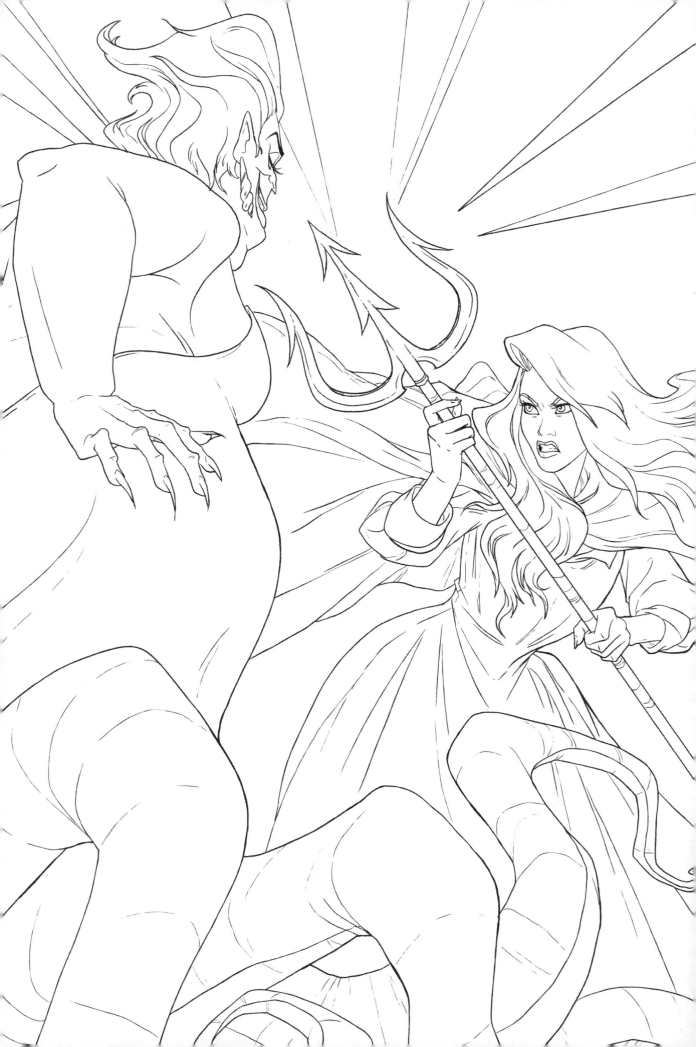

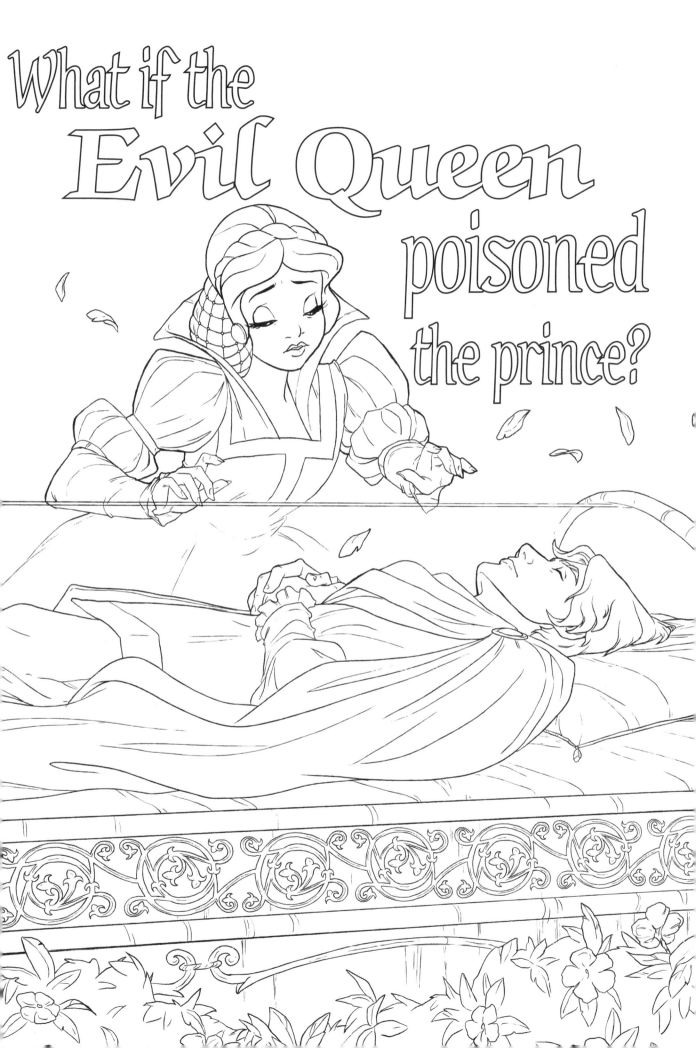

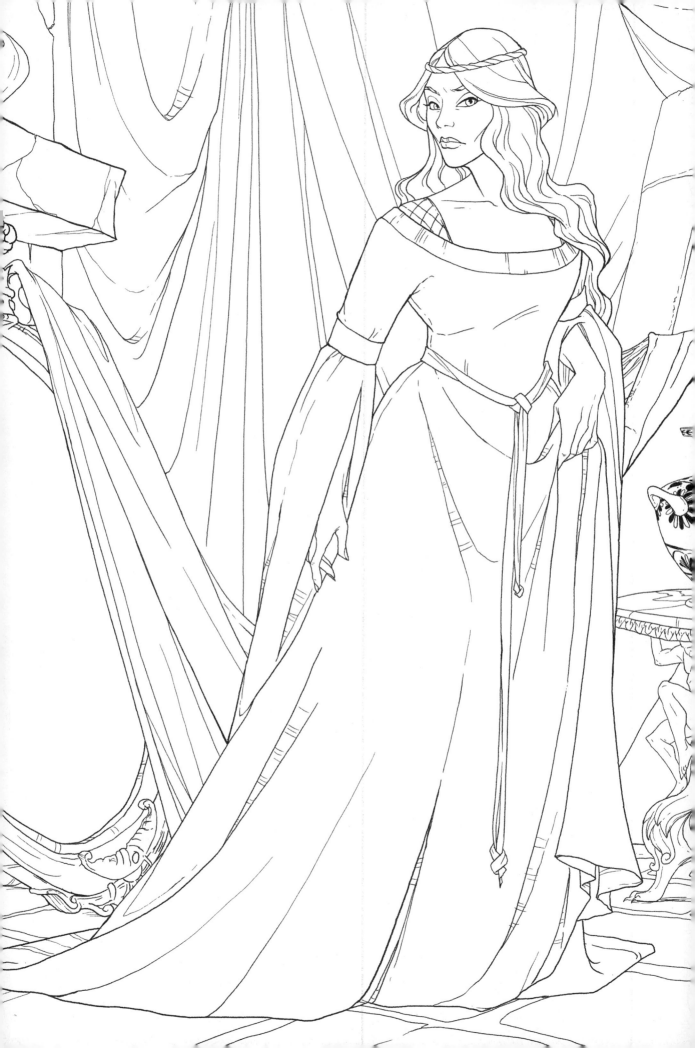

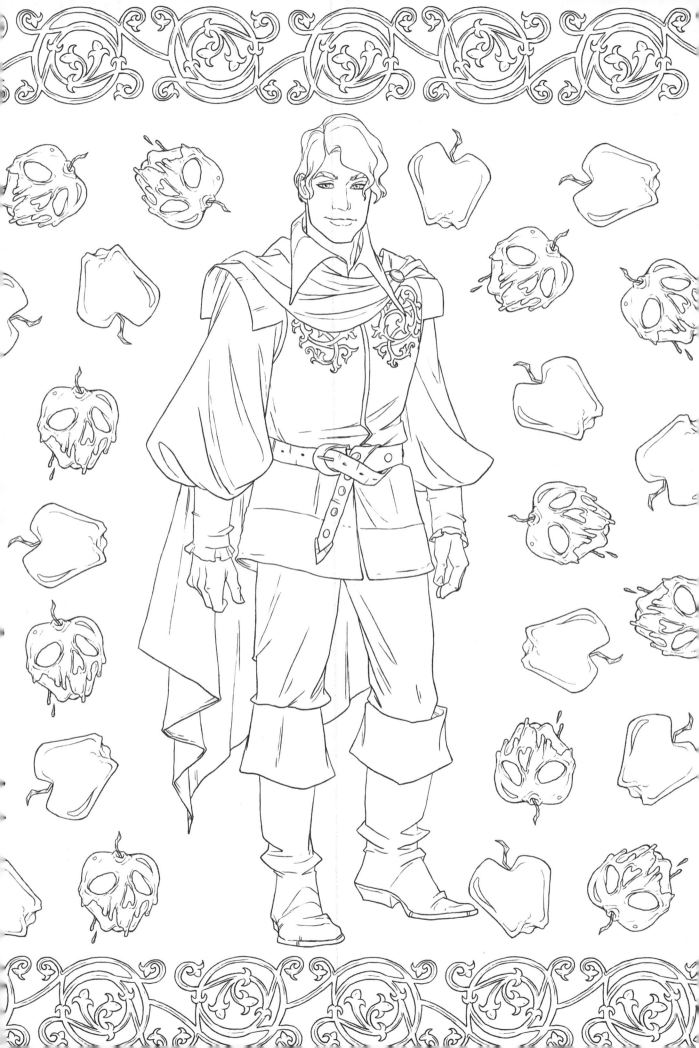

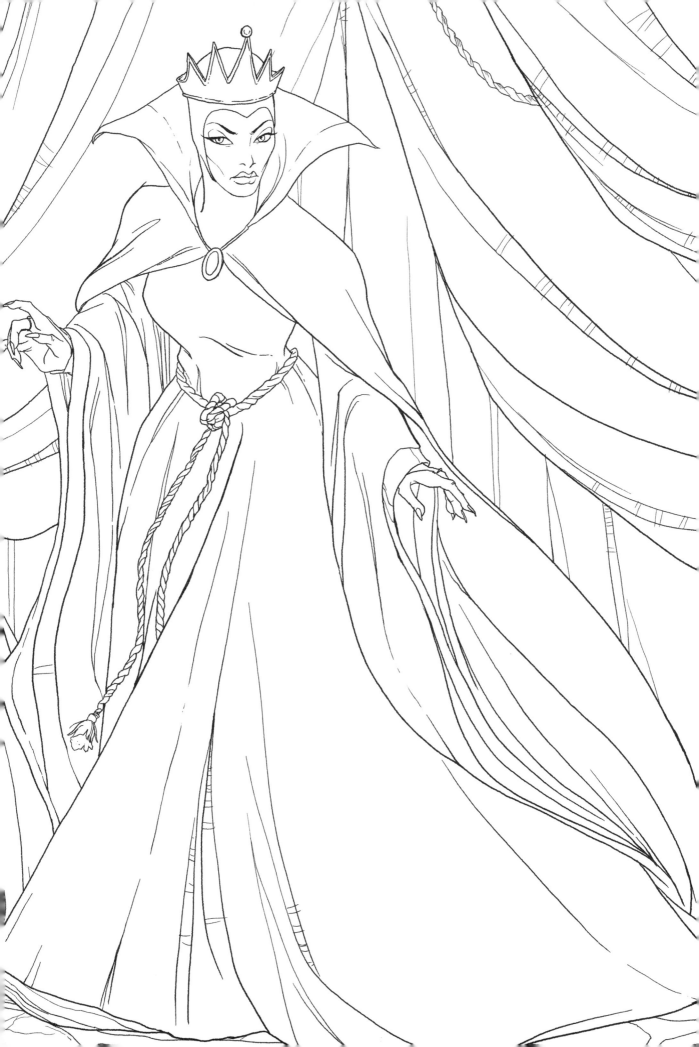

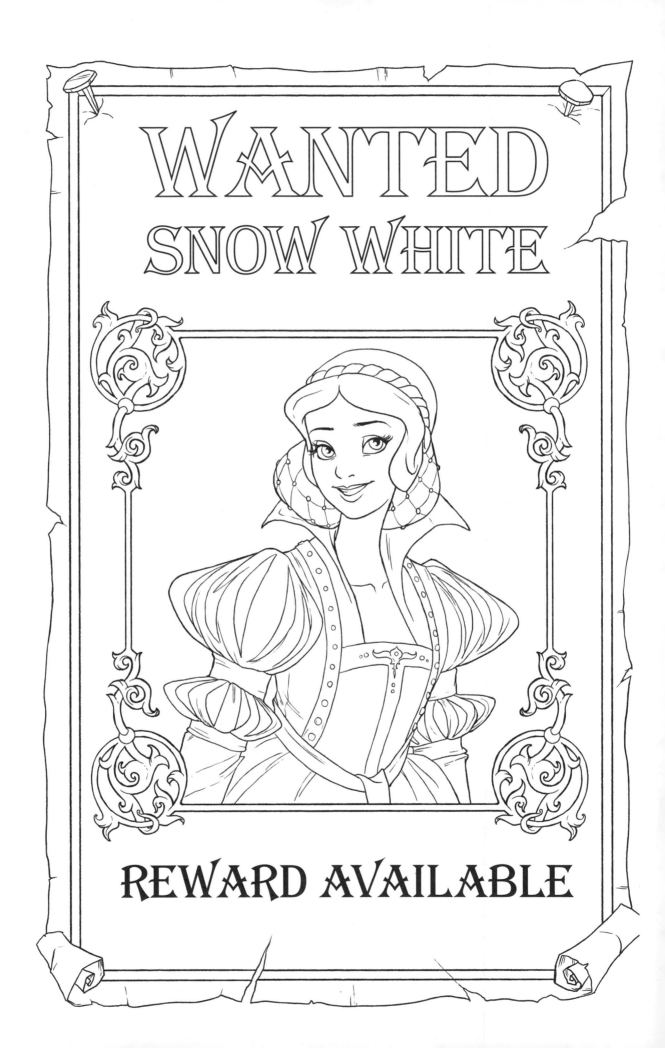

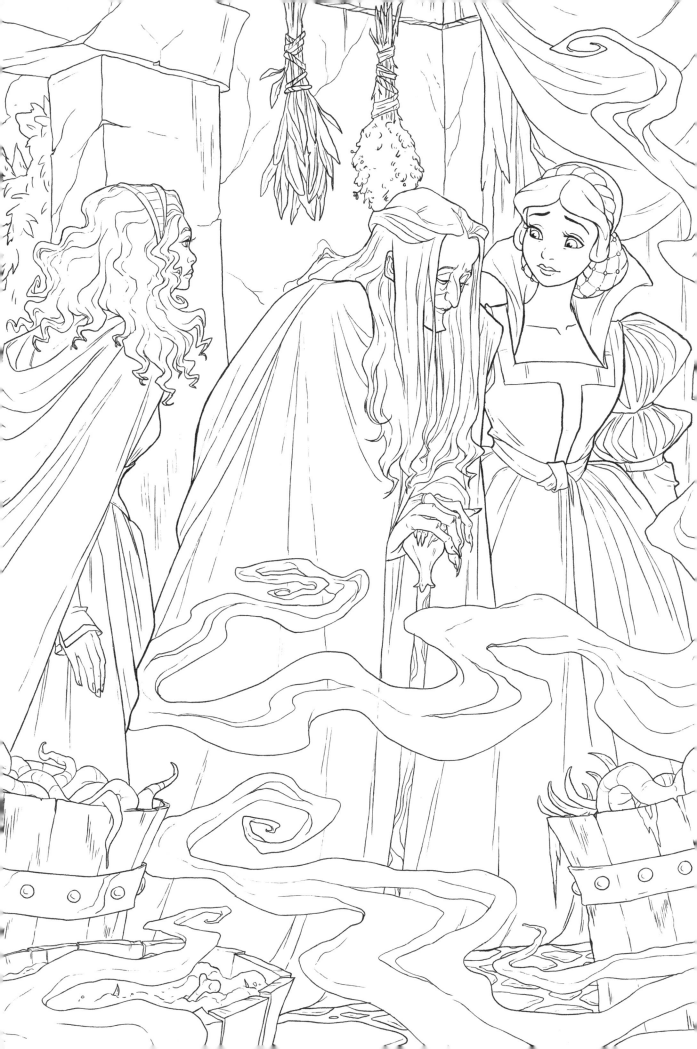

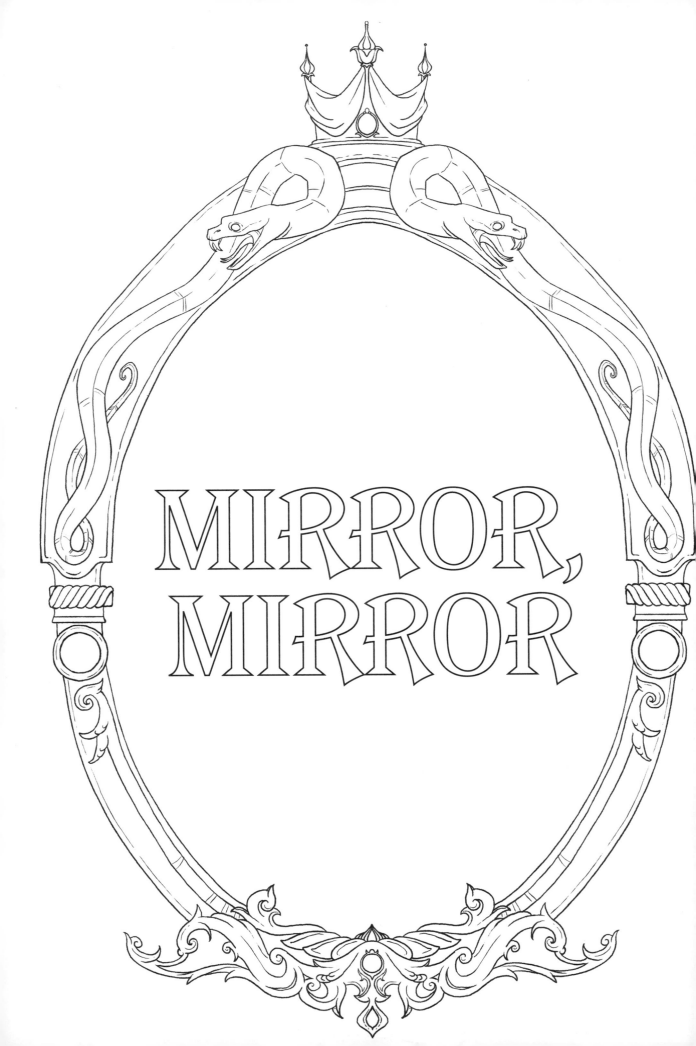

MIRROR,
MIRROR

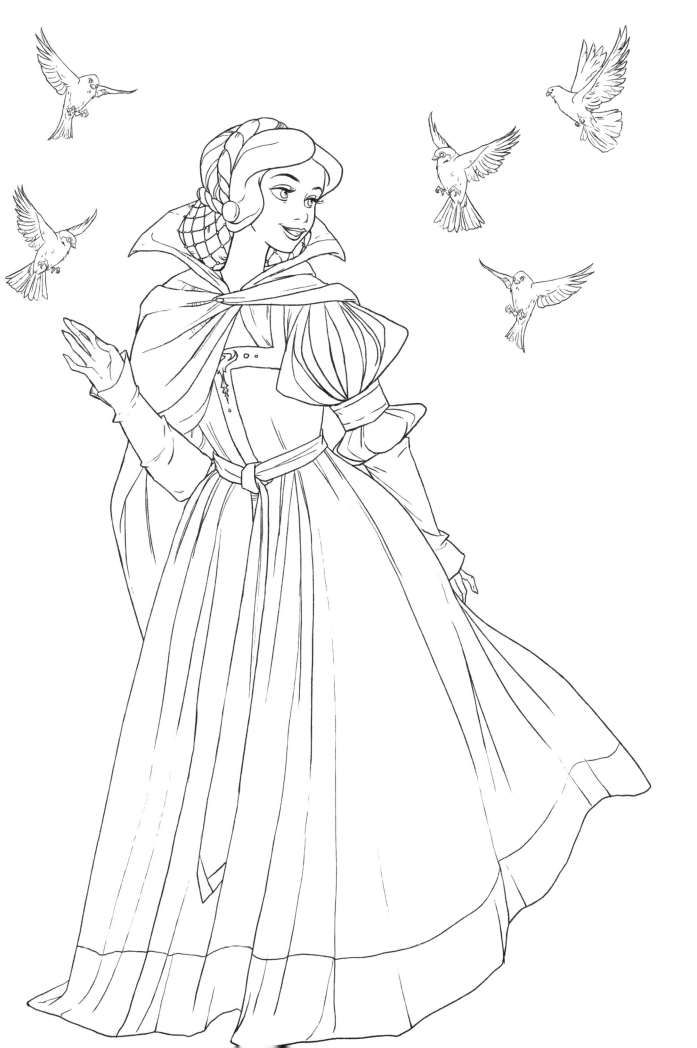

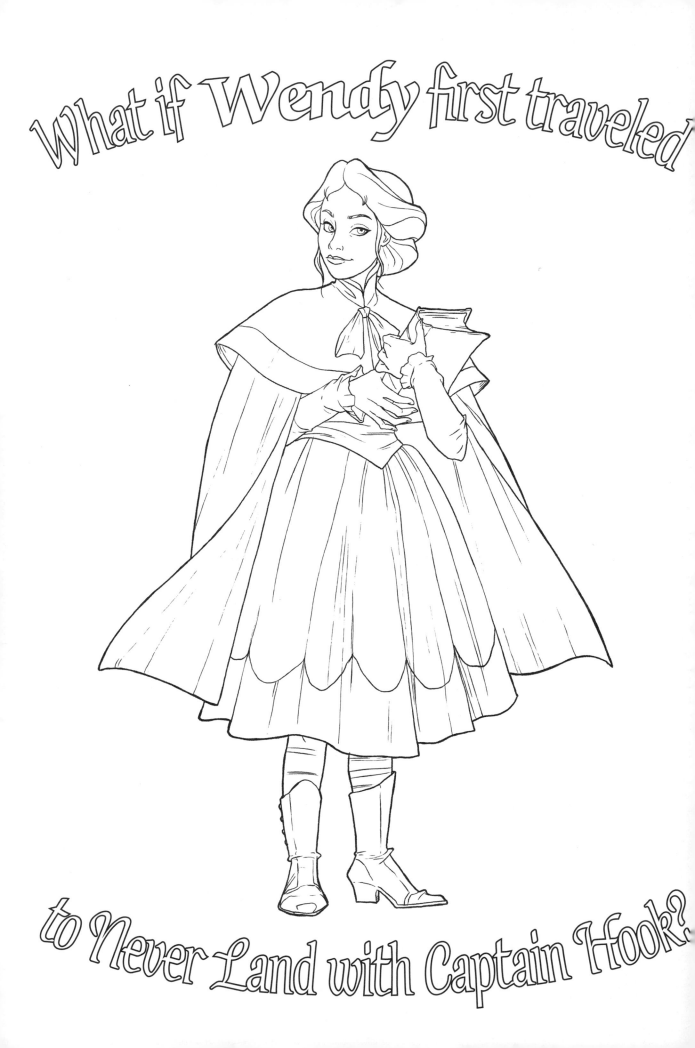

What if Wendy first traveled

to Never Land with Captain Hook?

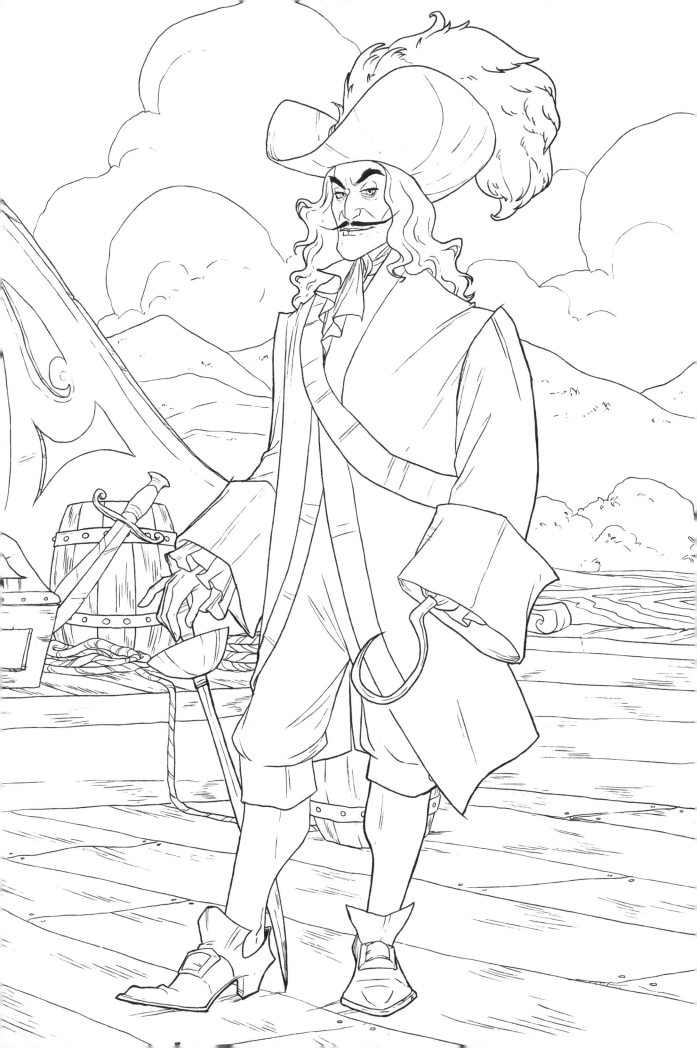

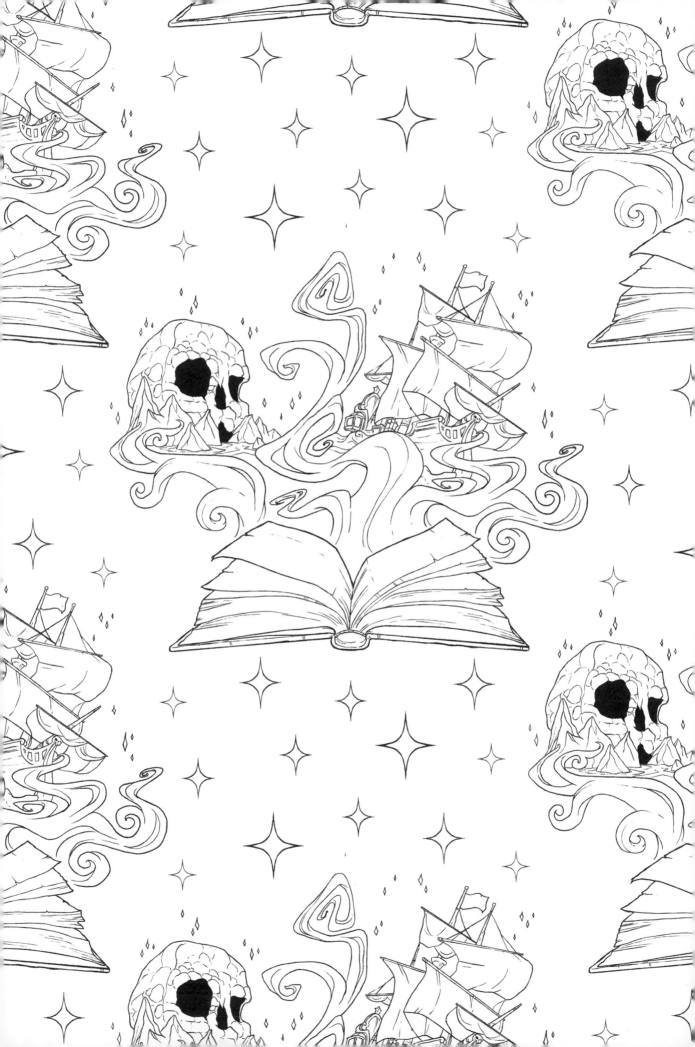

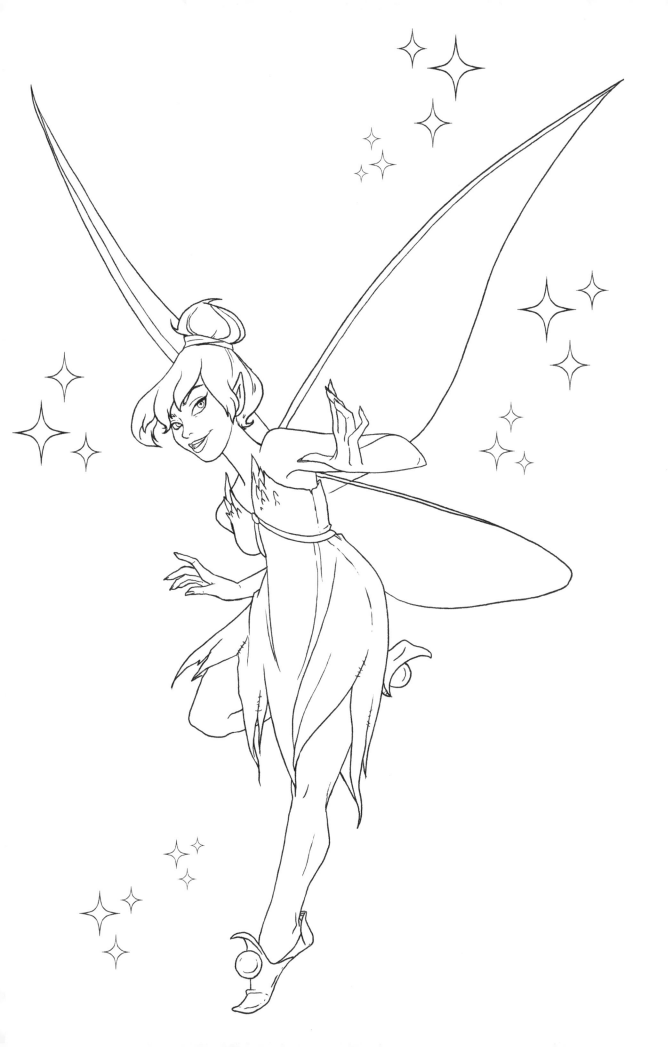

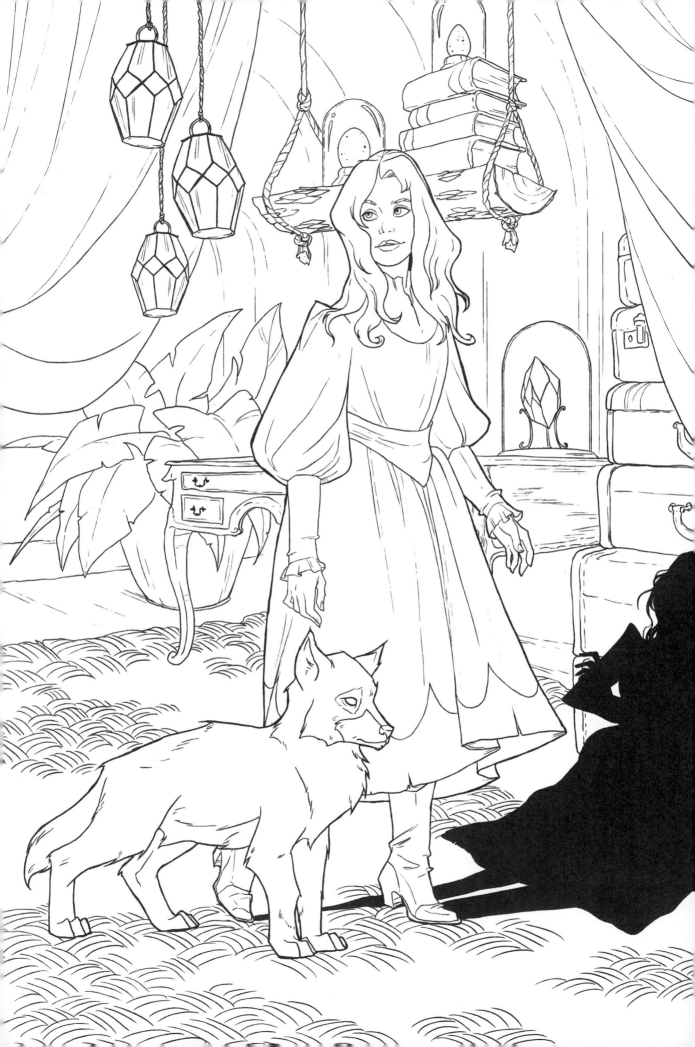

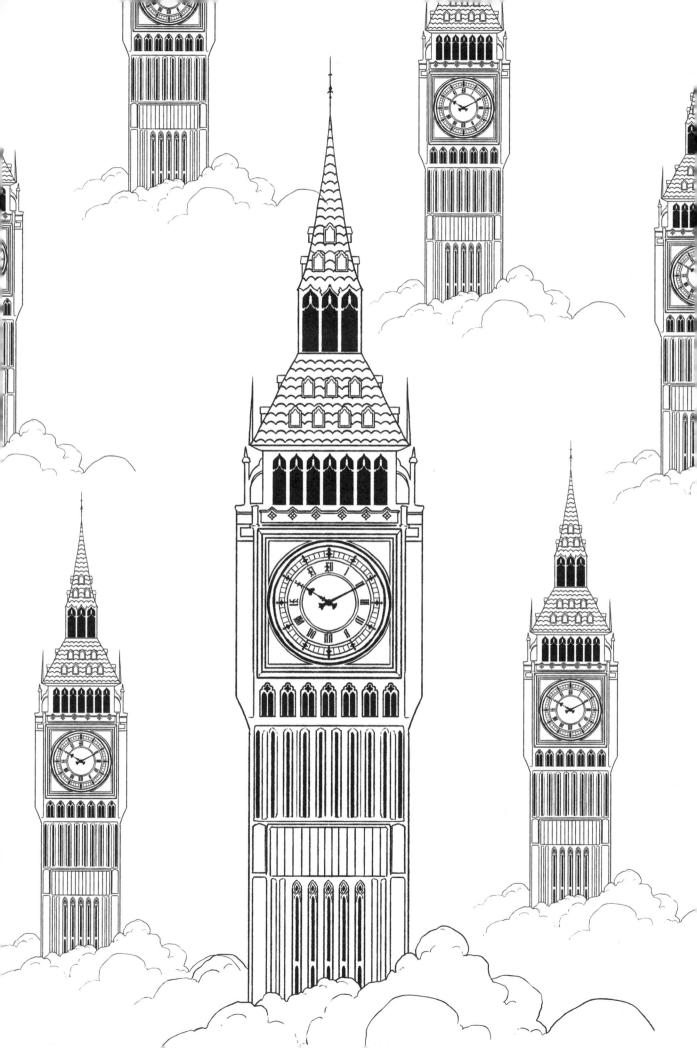

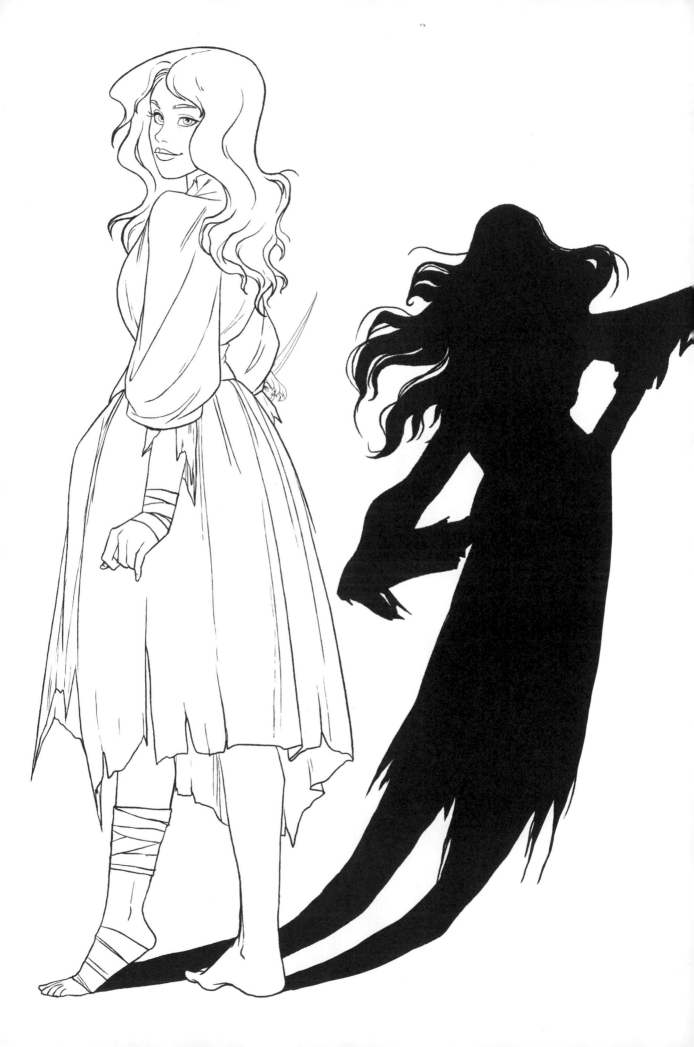

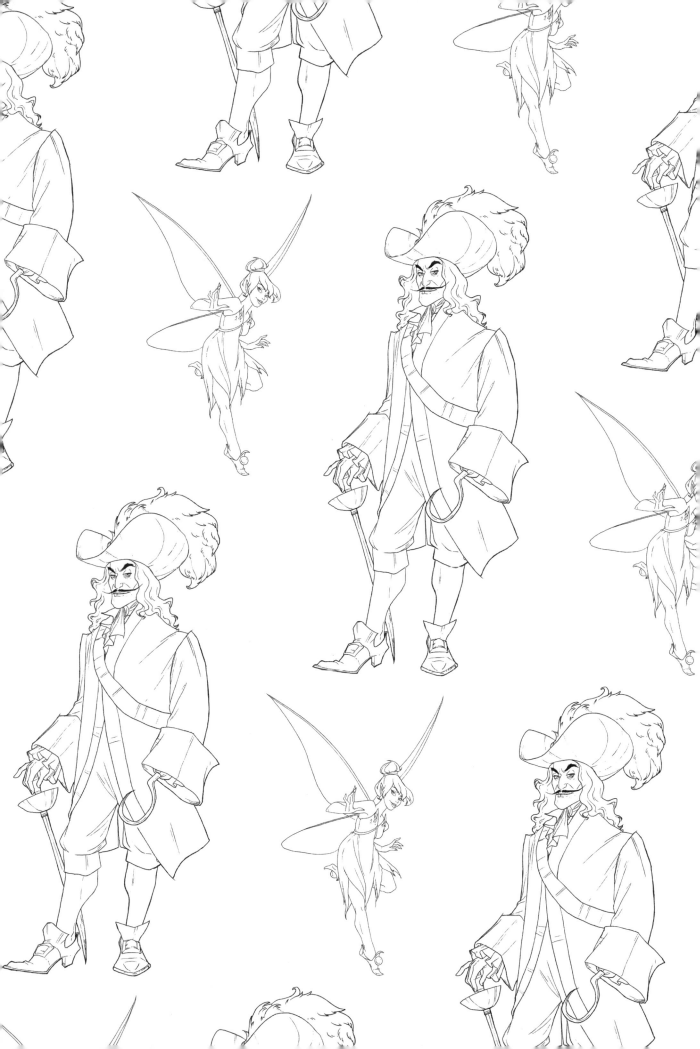

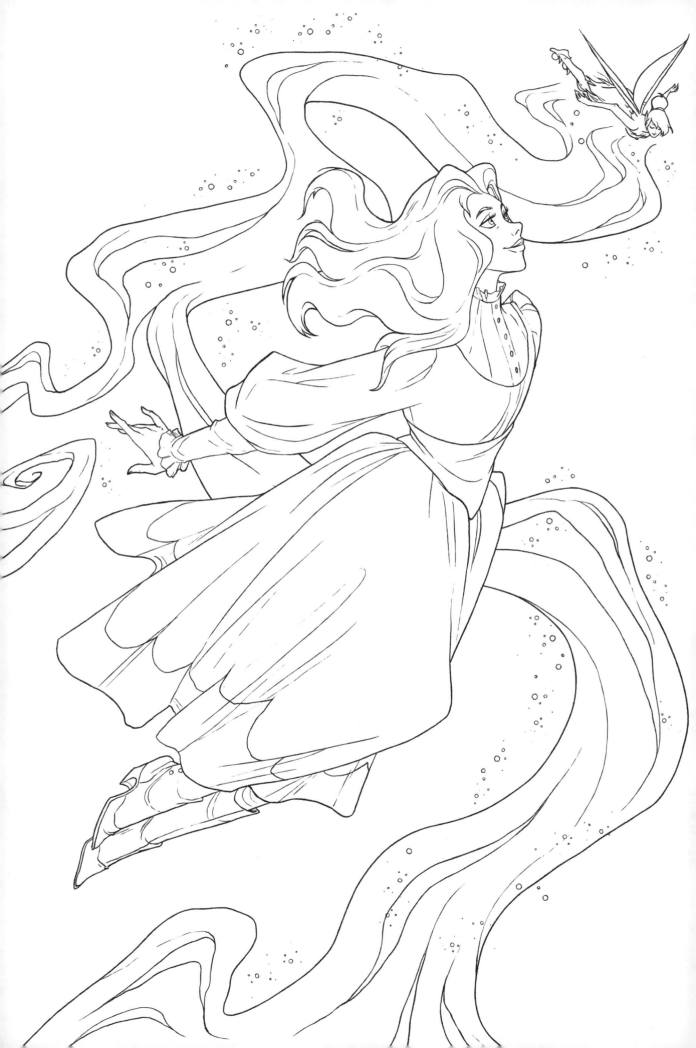

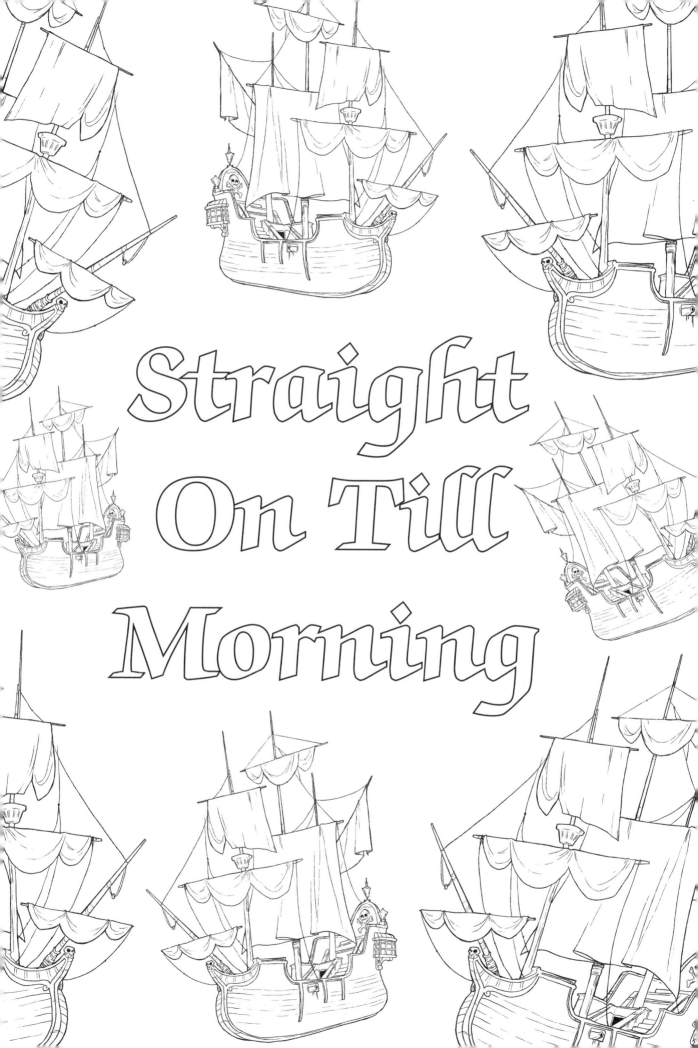

Straight On Till Morning

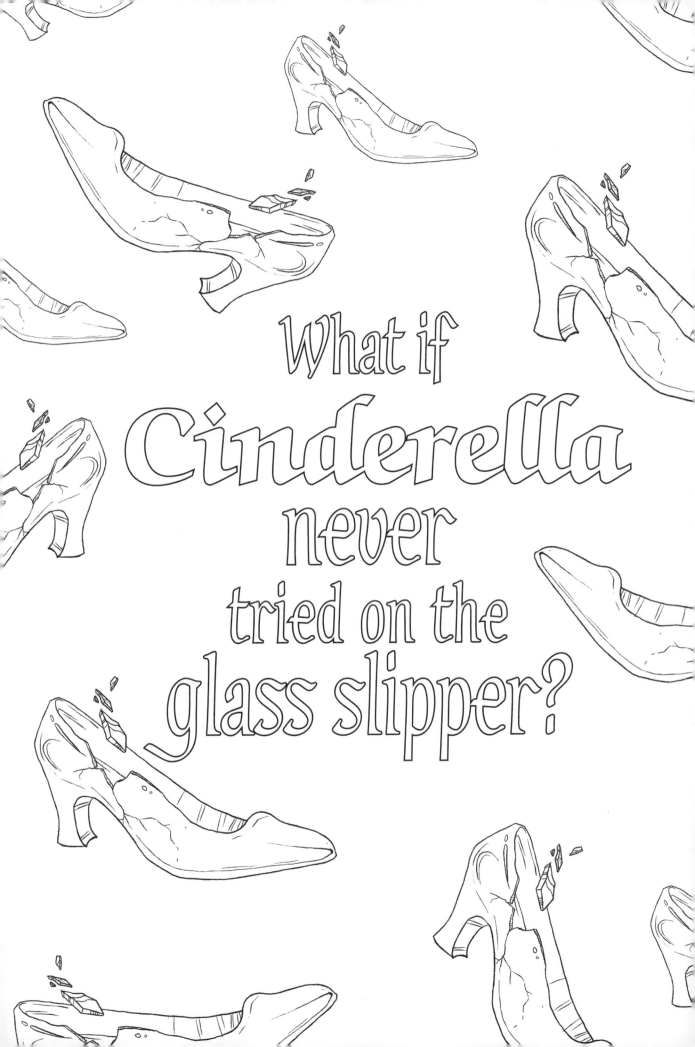

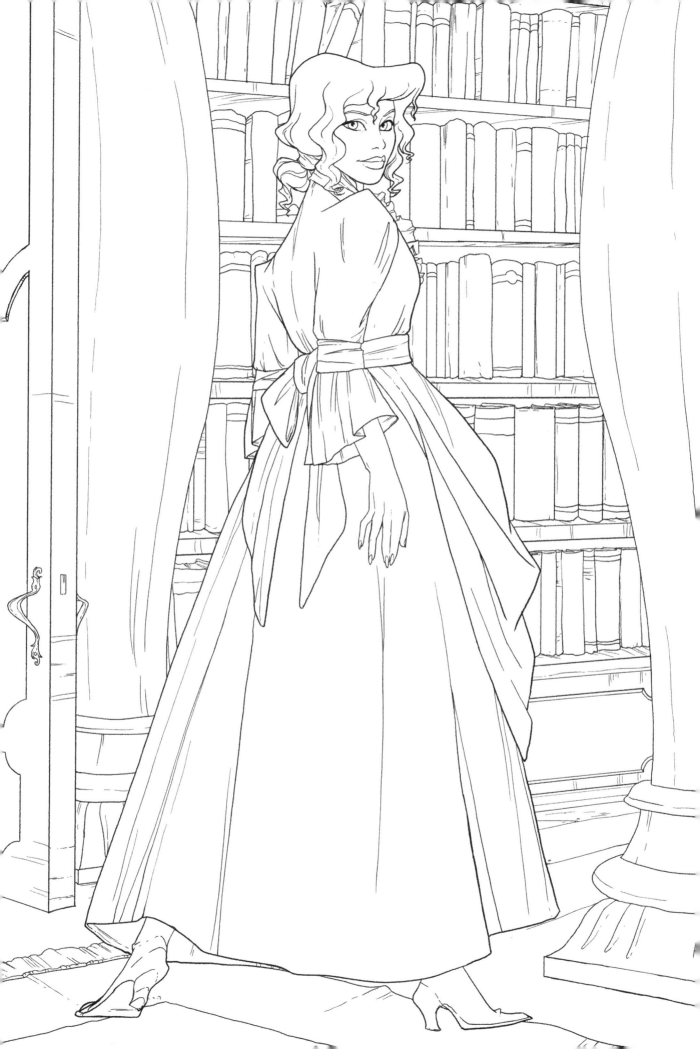

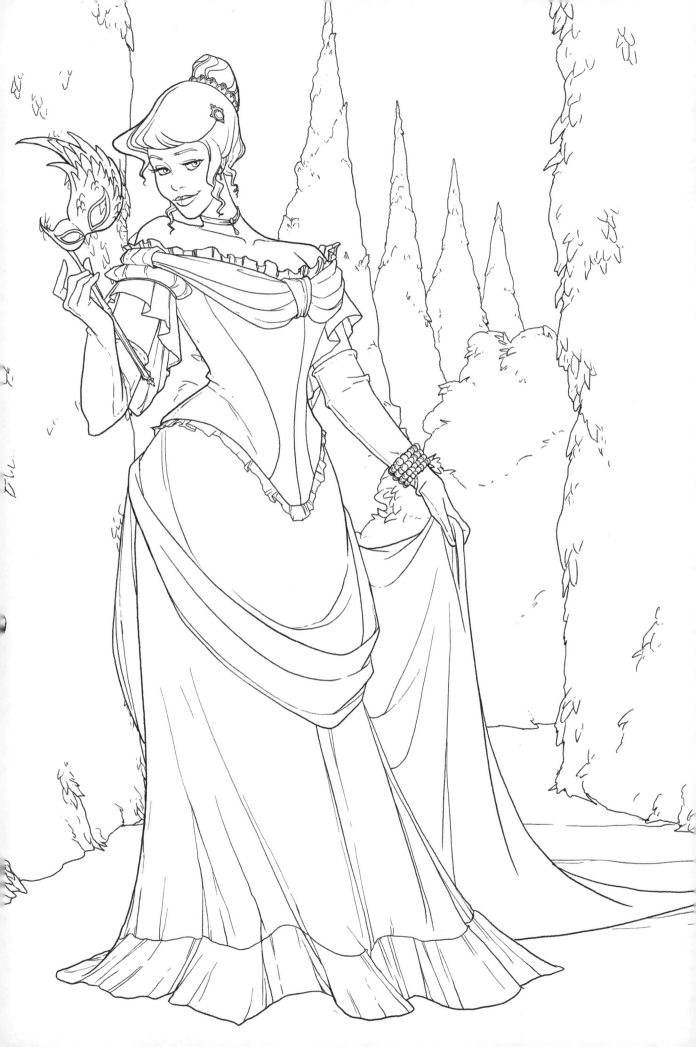

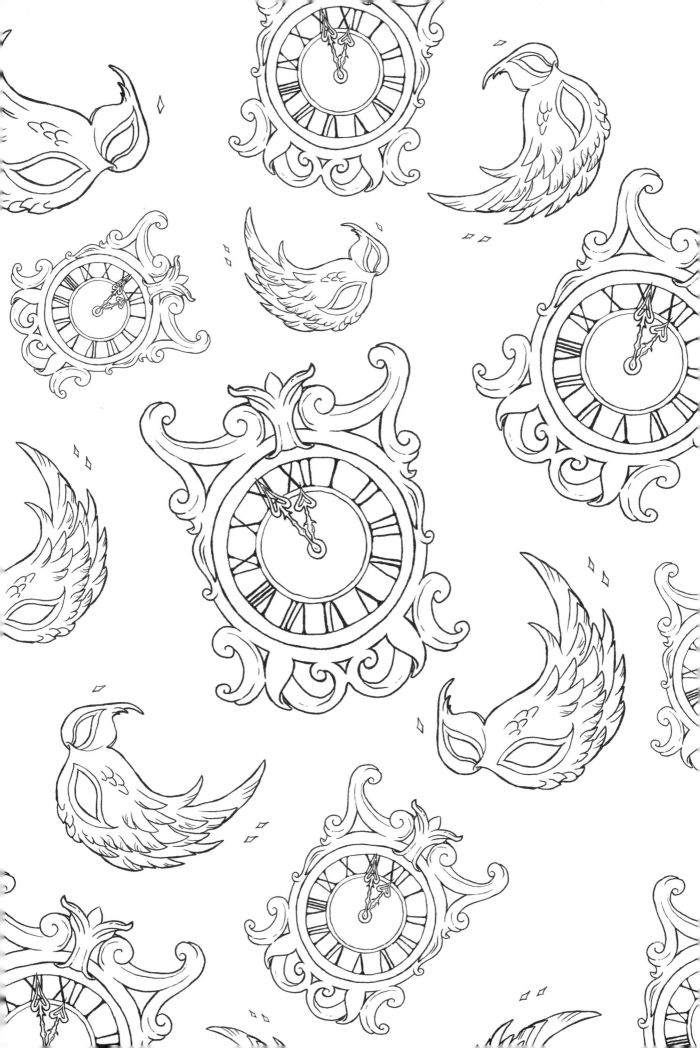

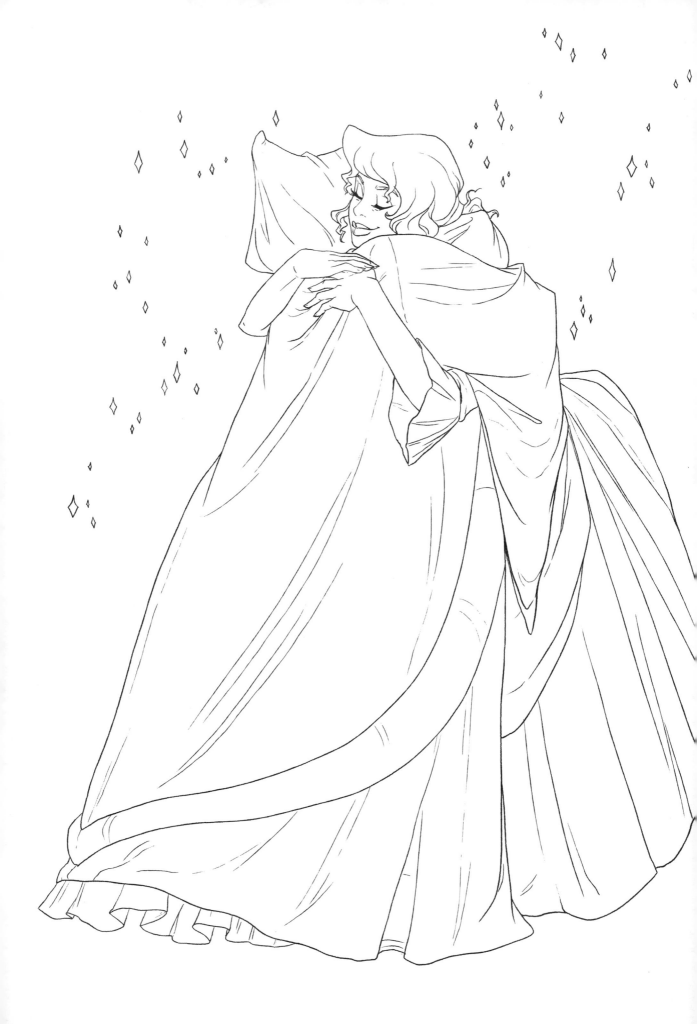

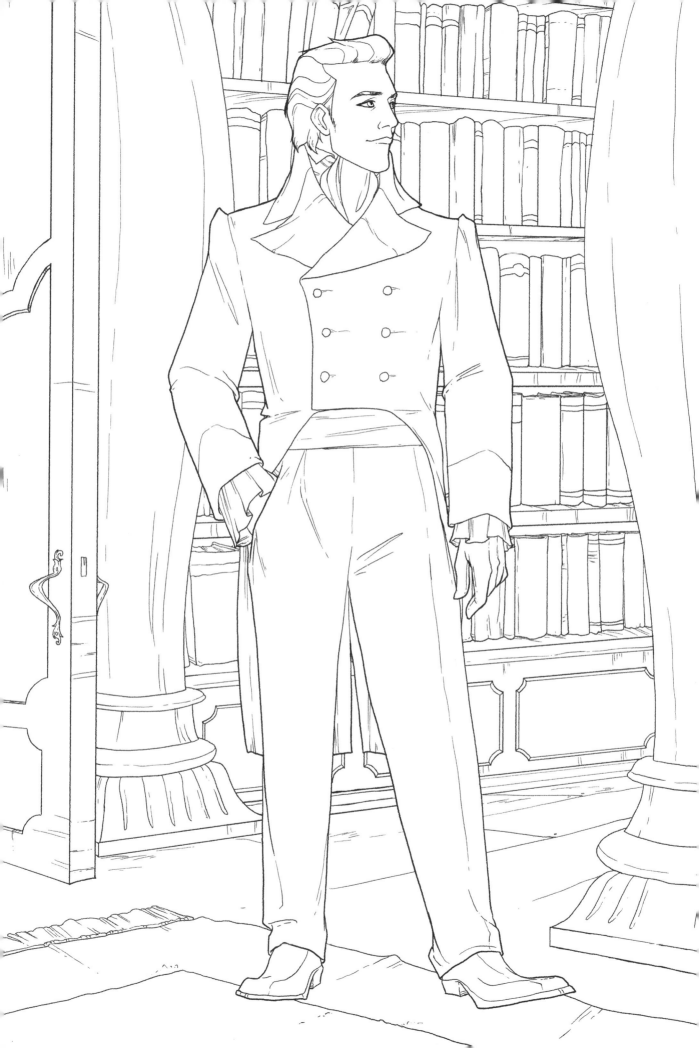

So This Is Love

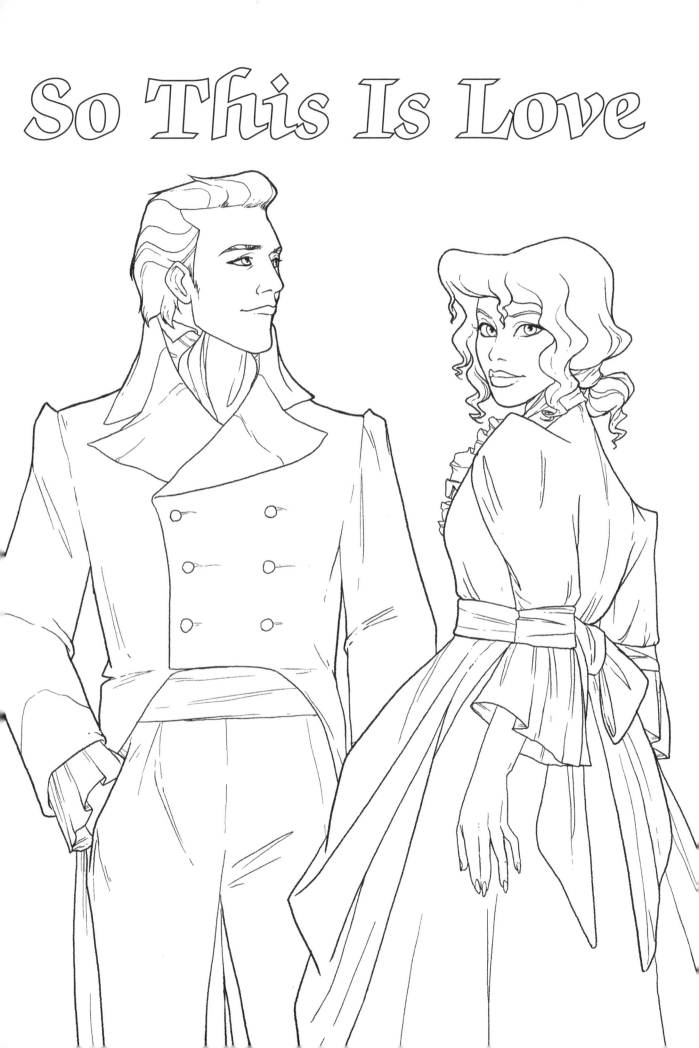

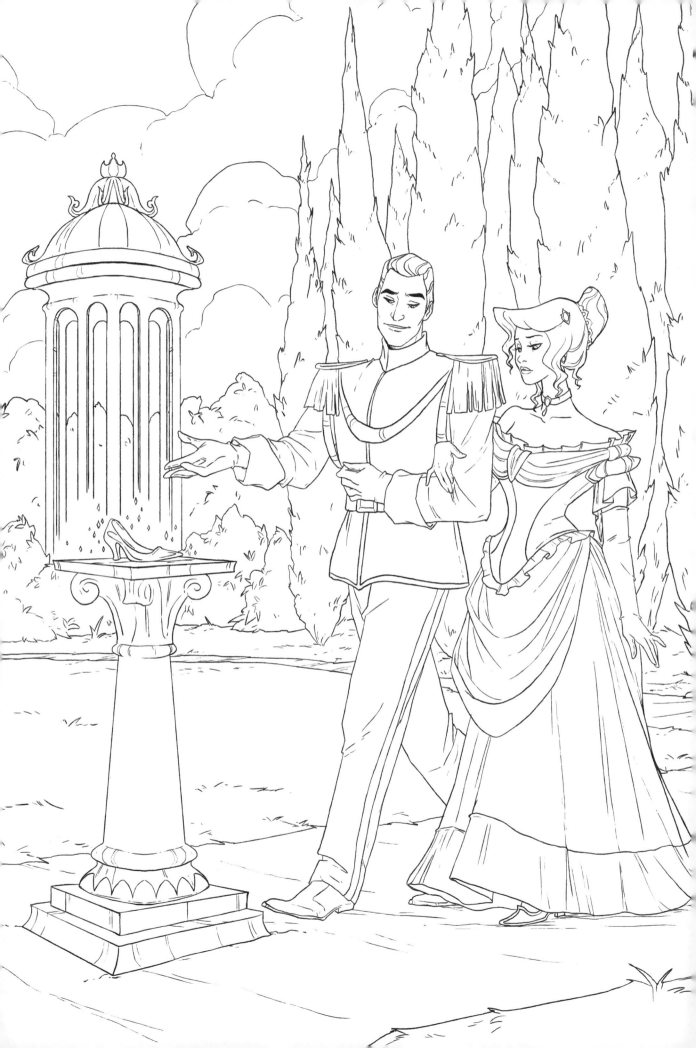

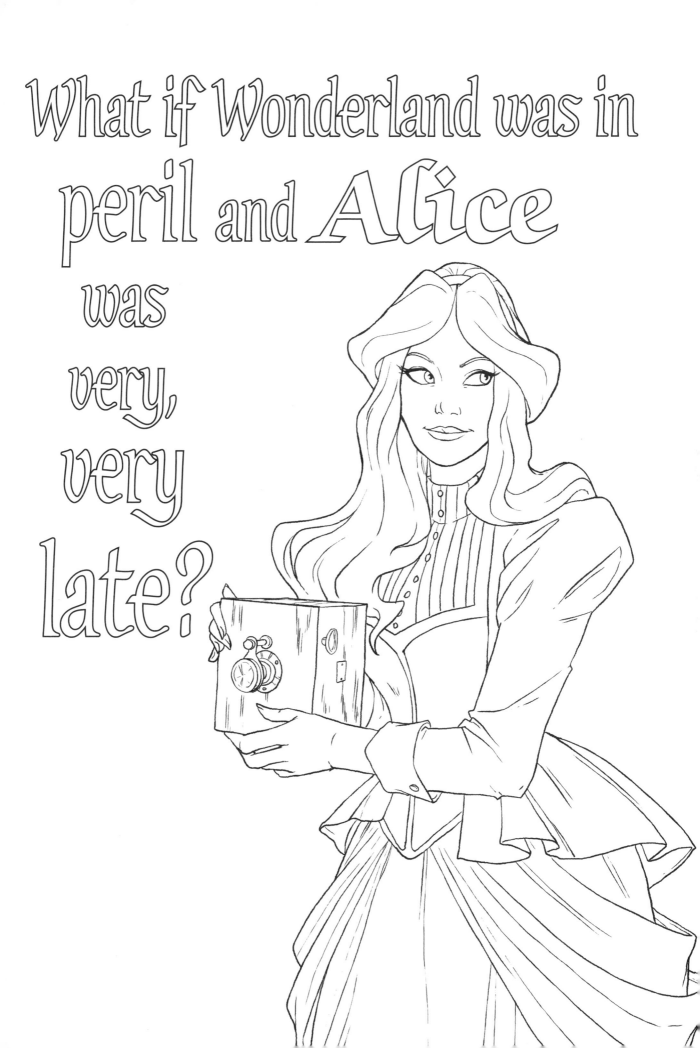

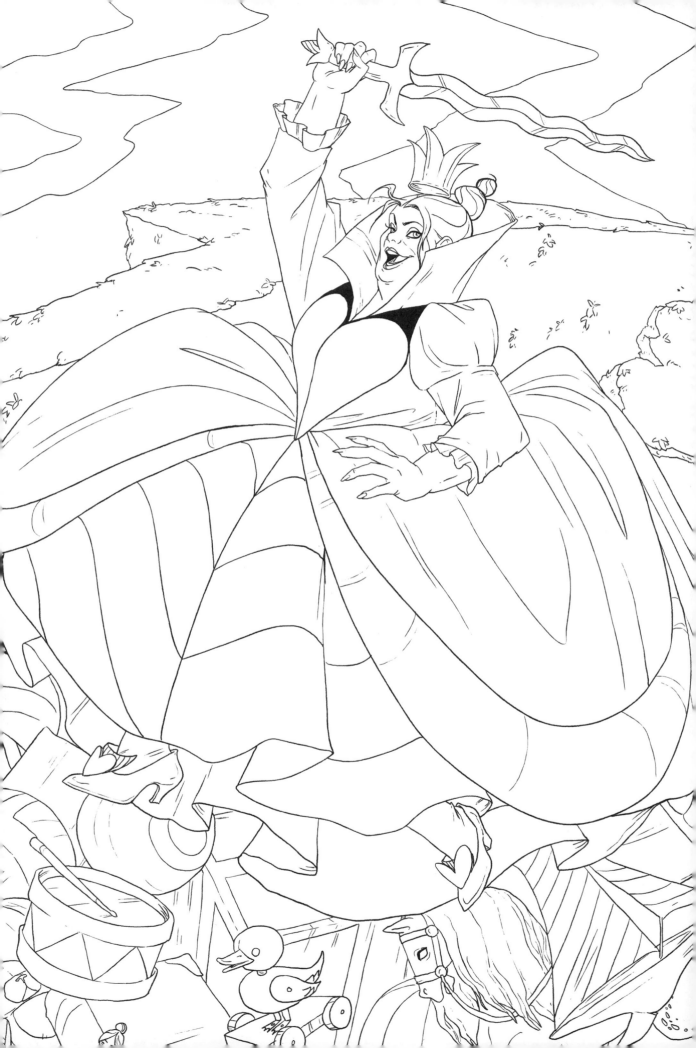

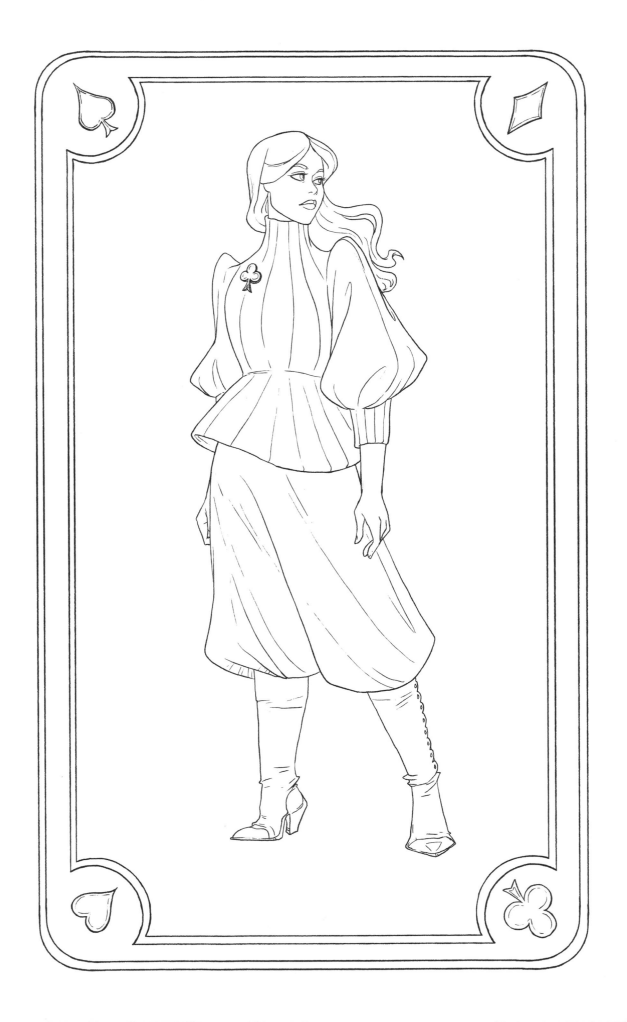

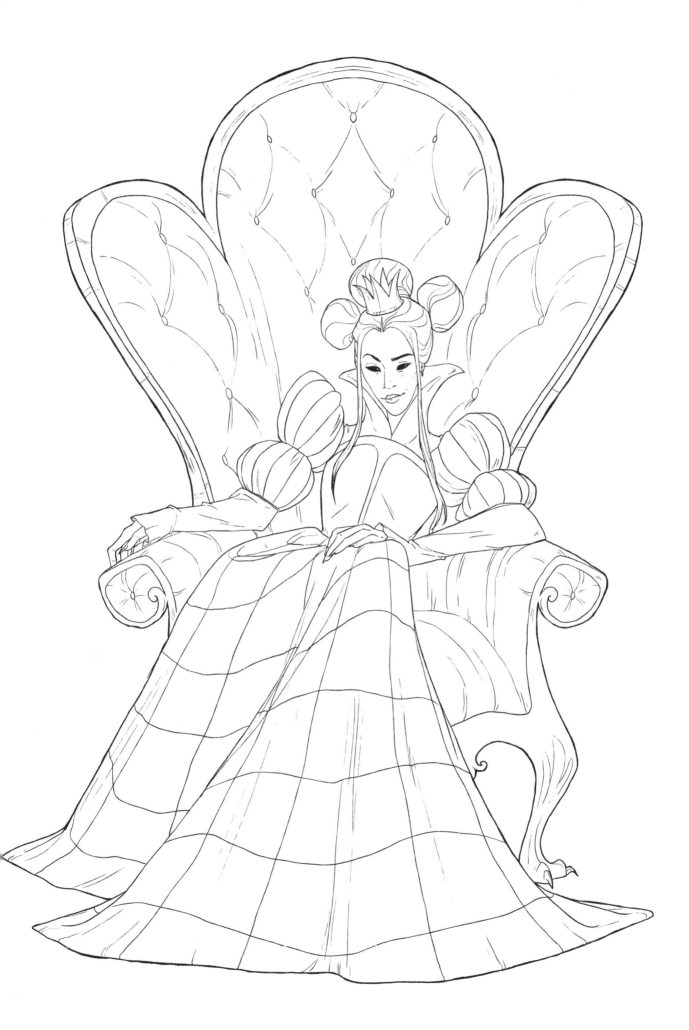

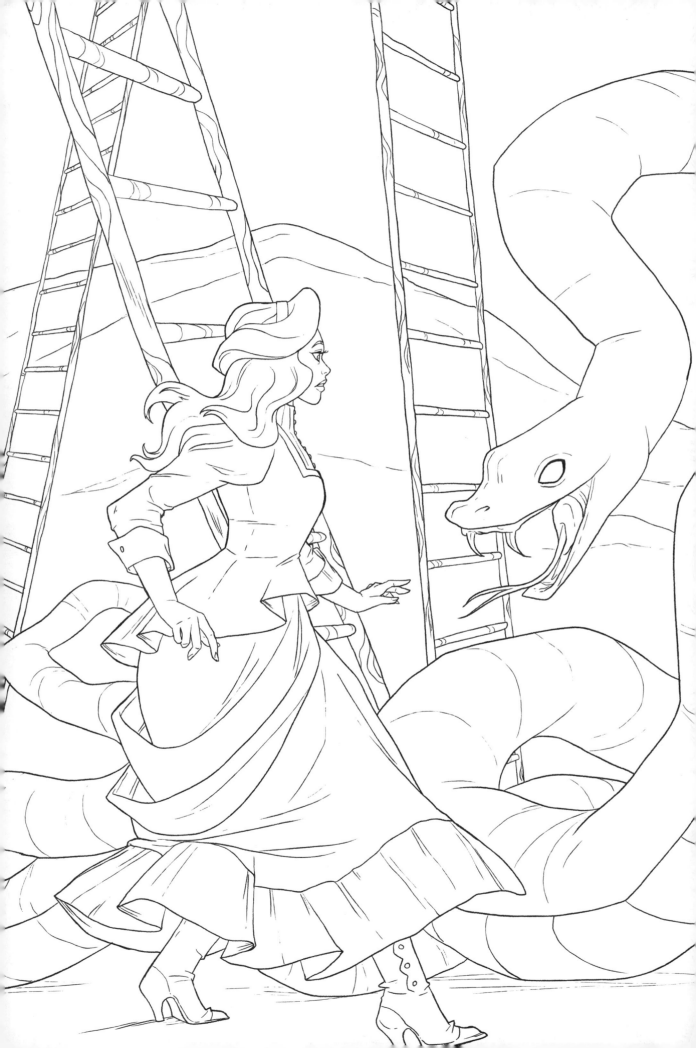

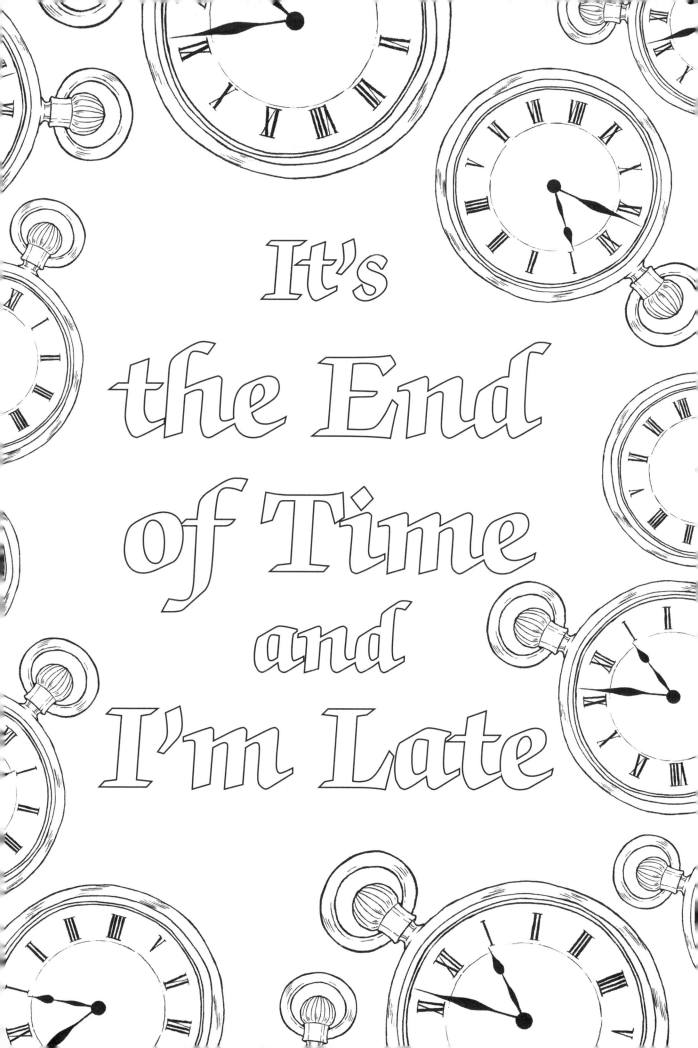

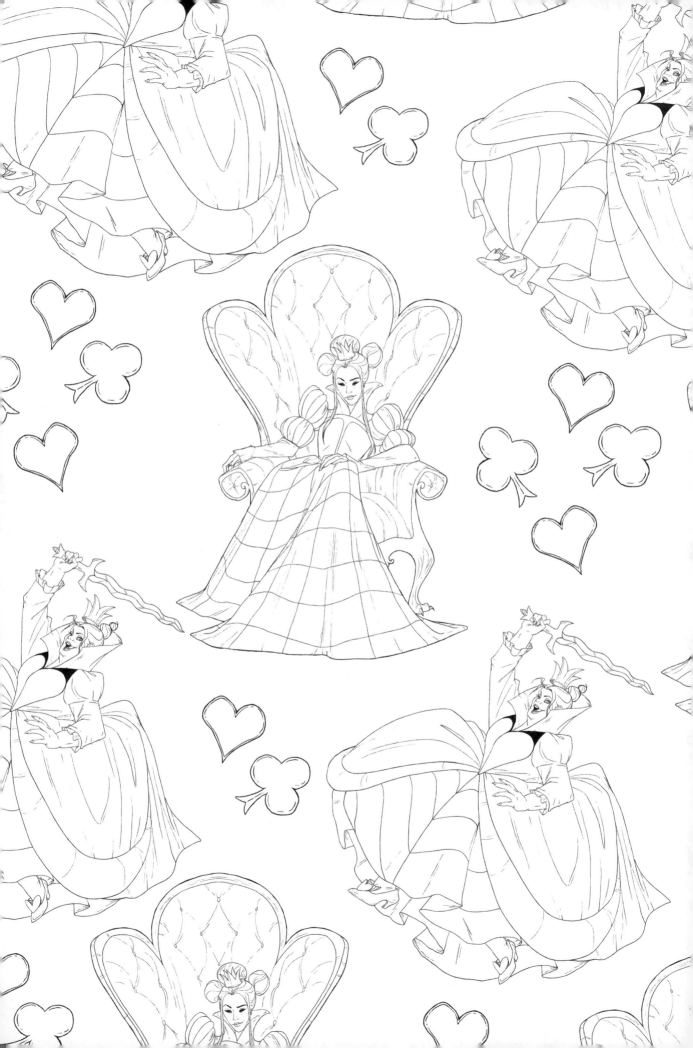

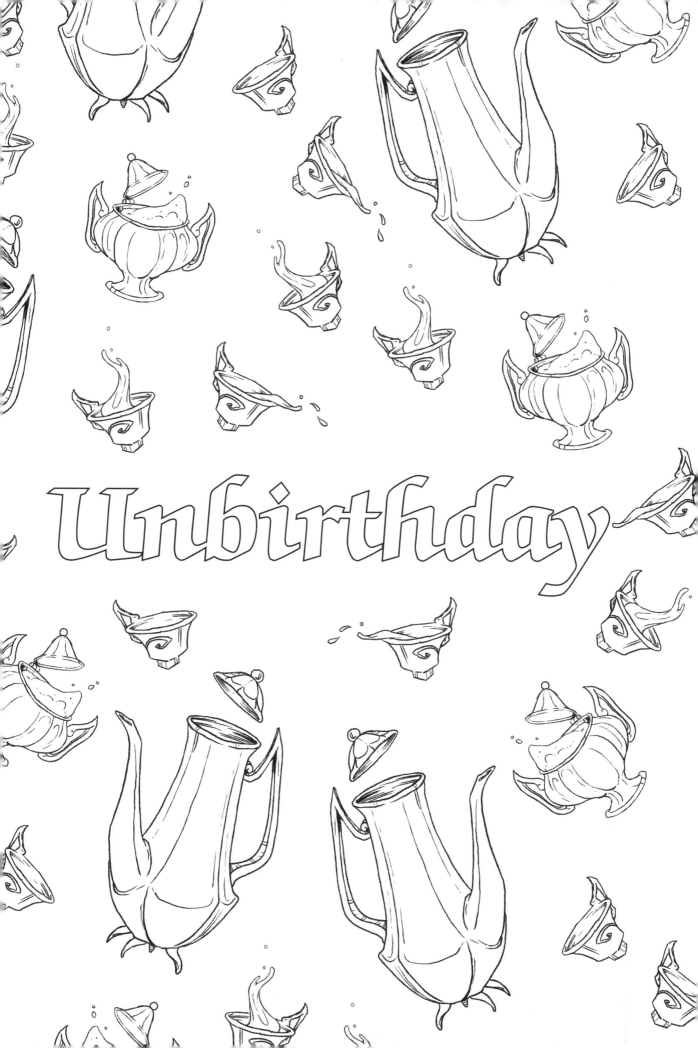

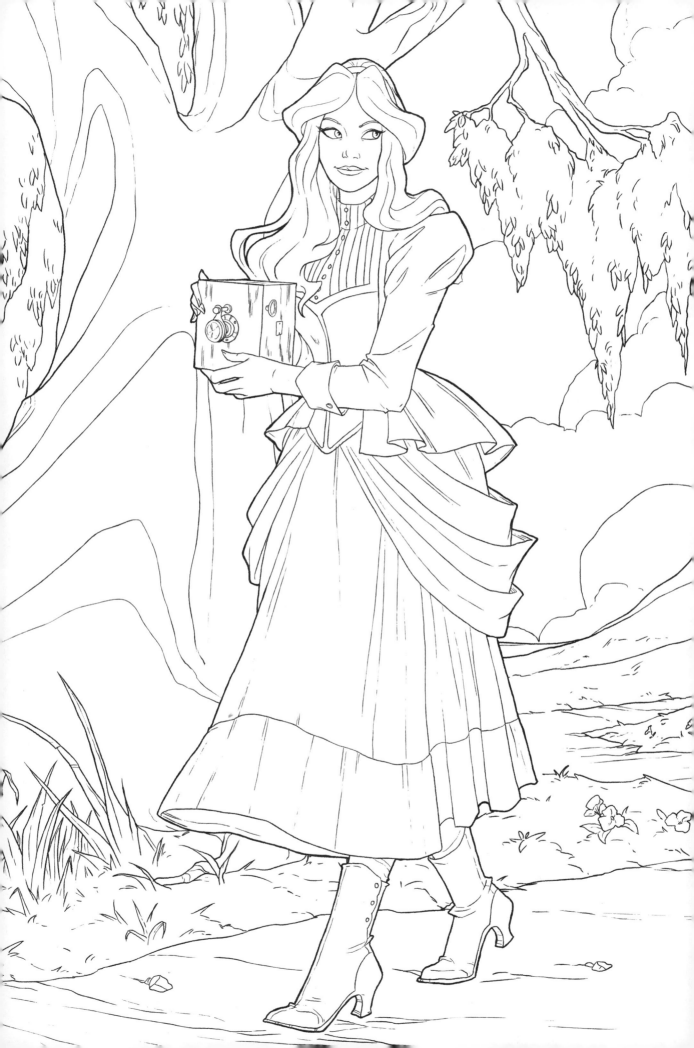

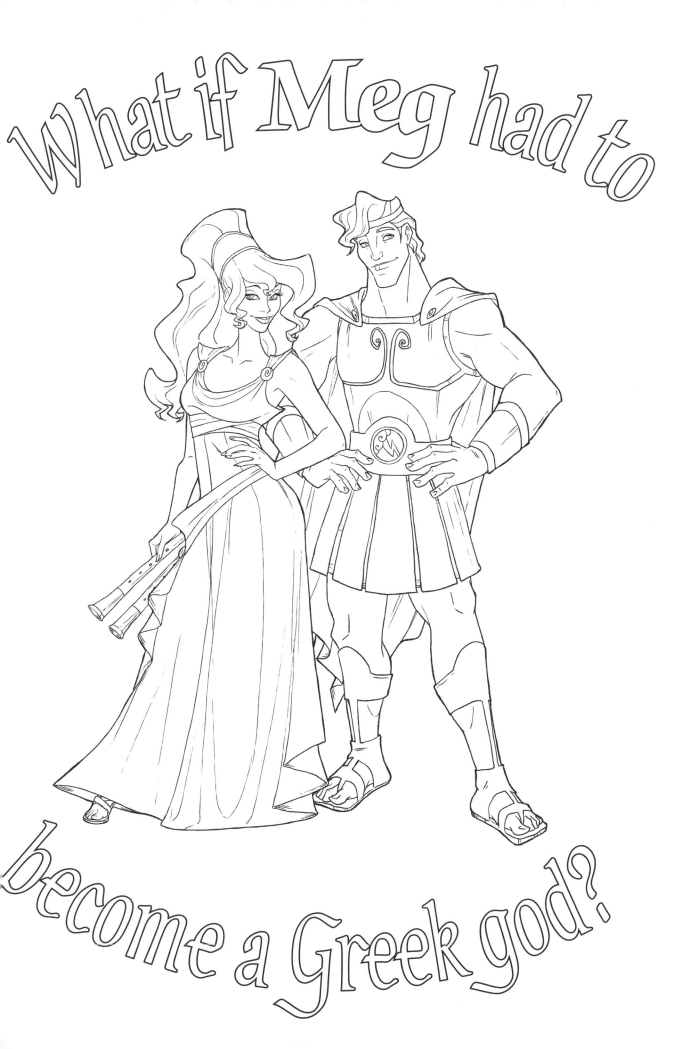

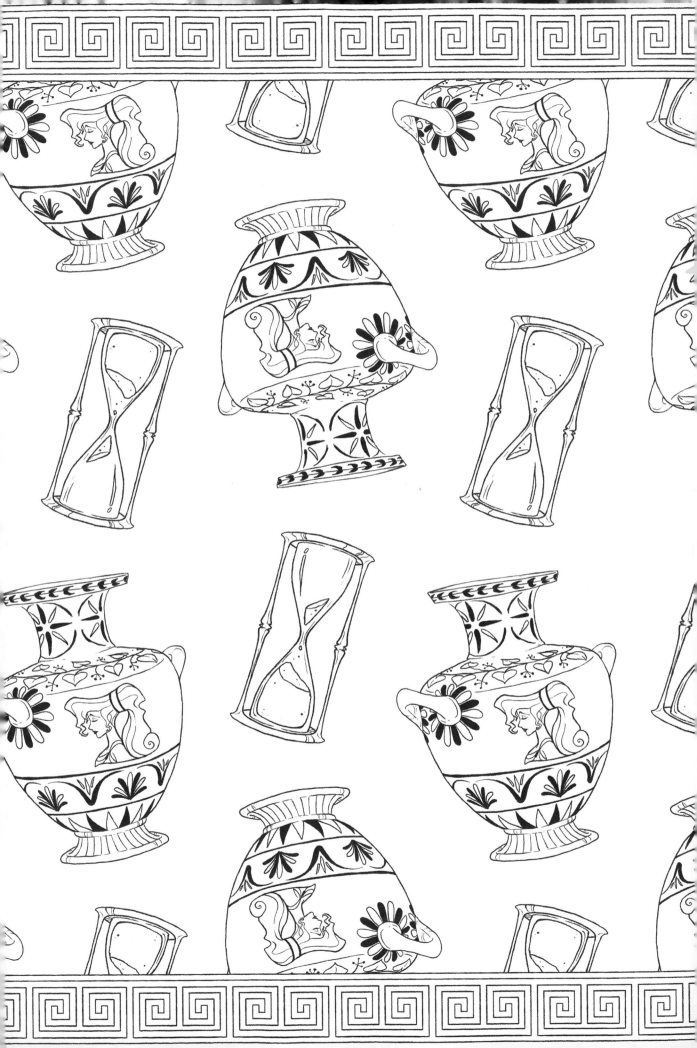

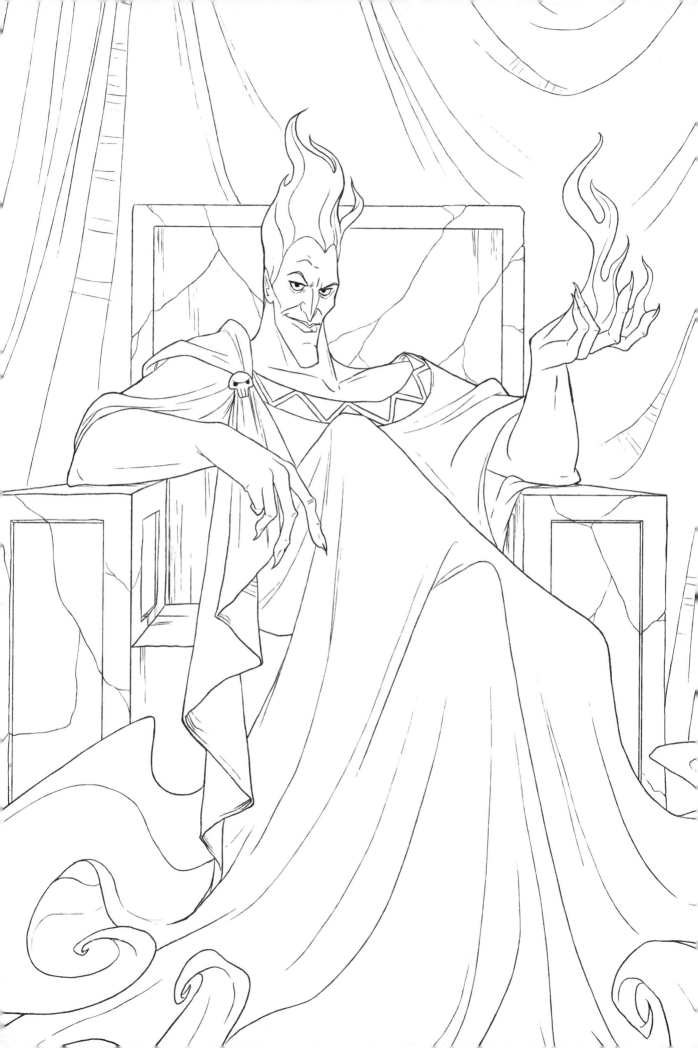

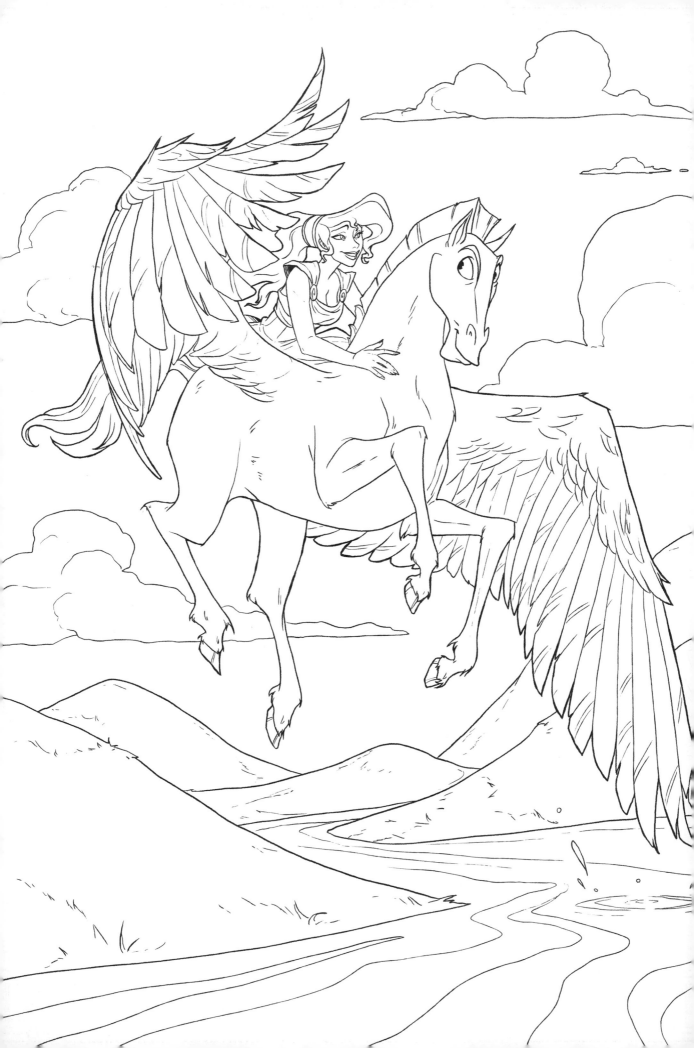

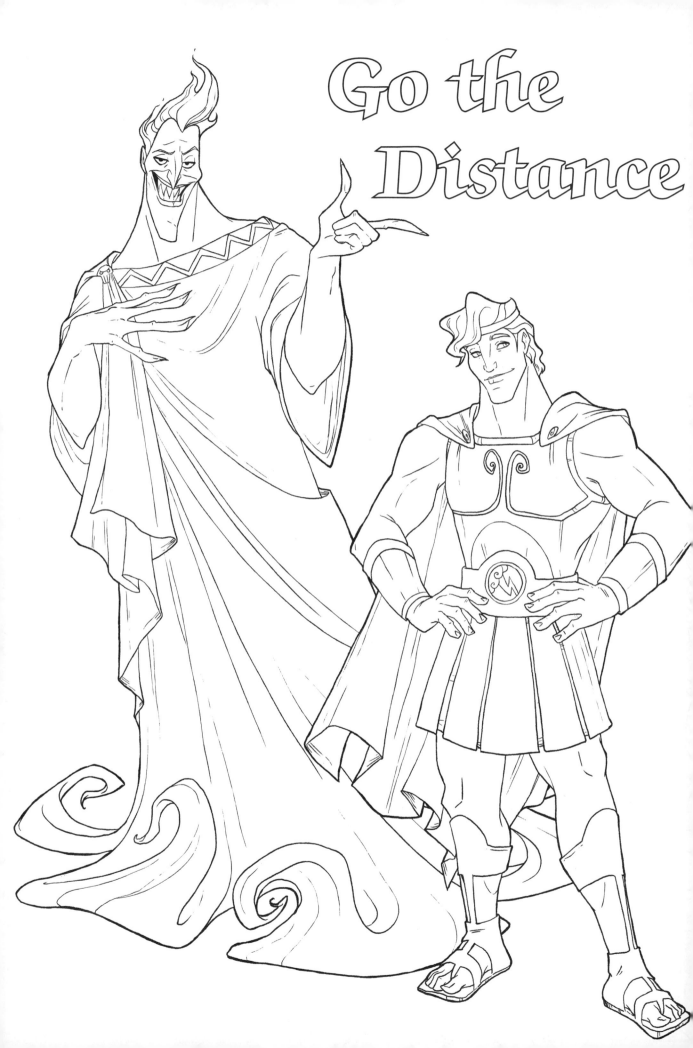

Go the Distance

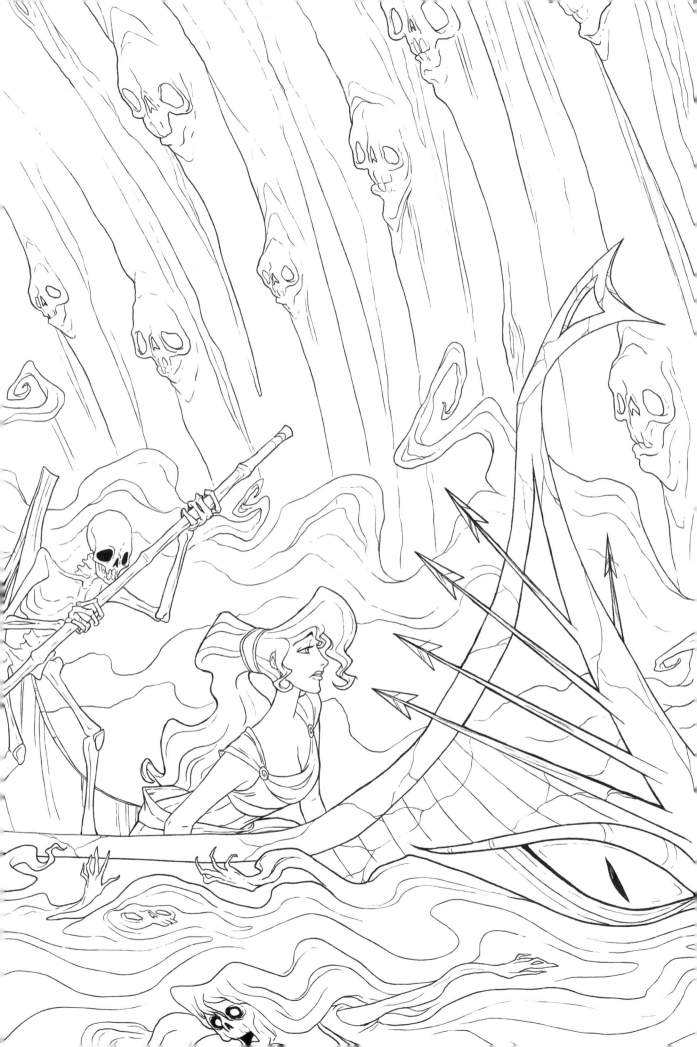

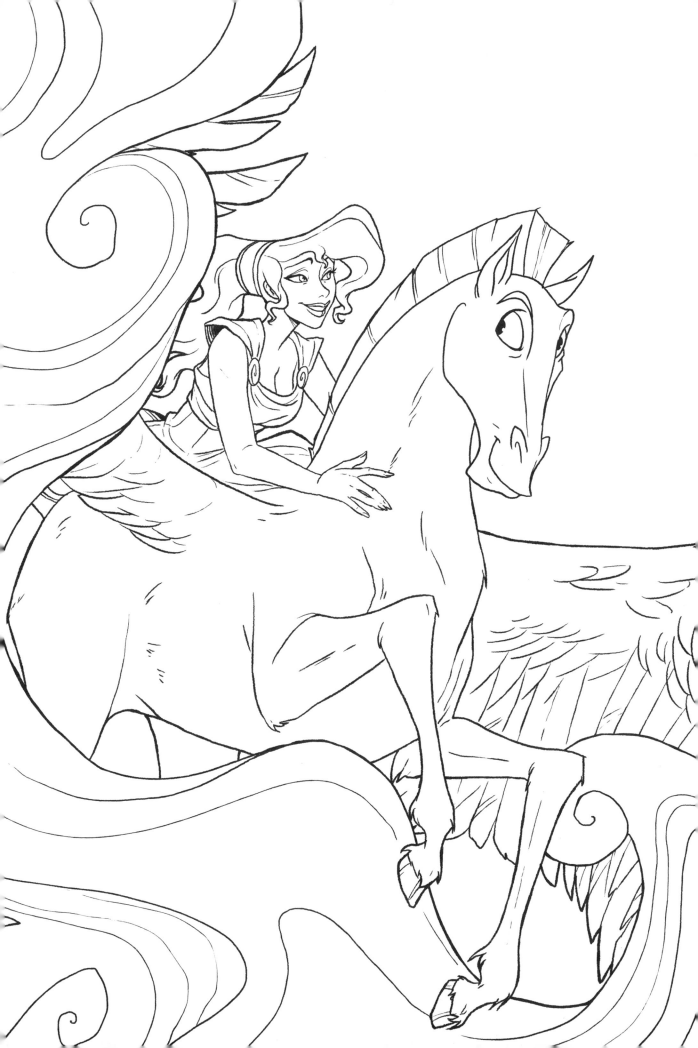

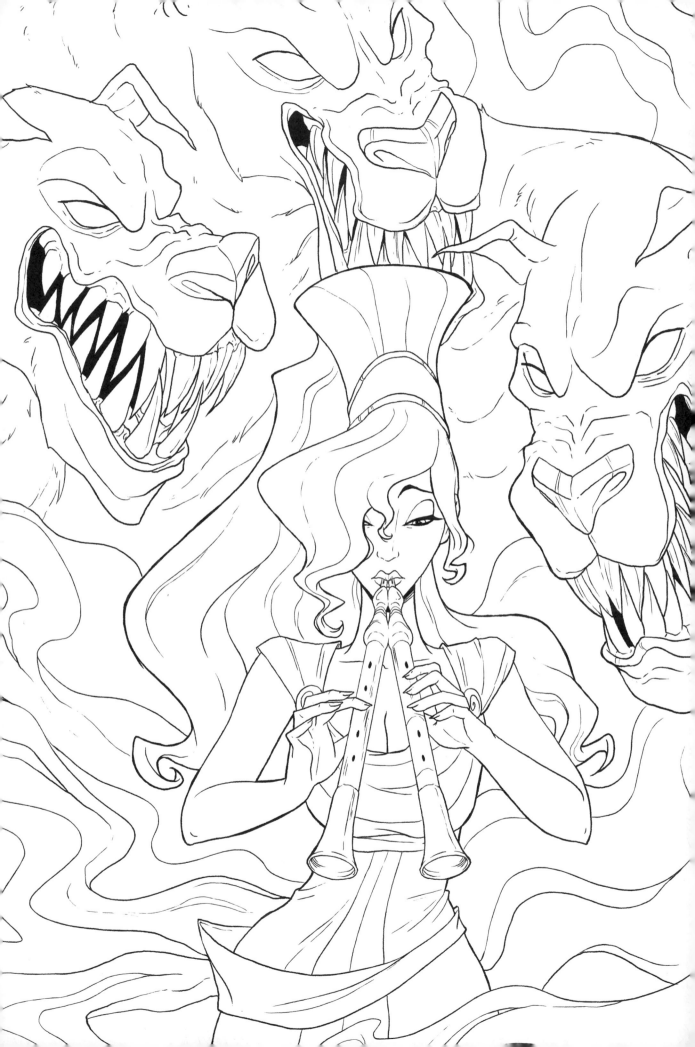

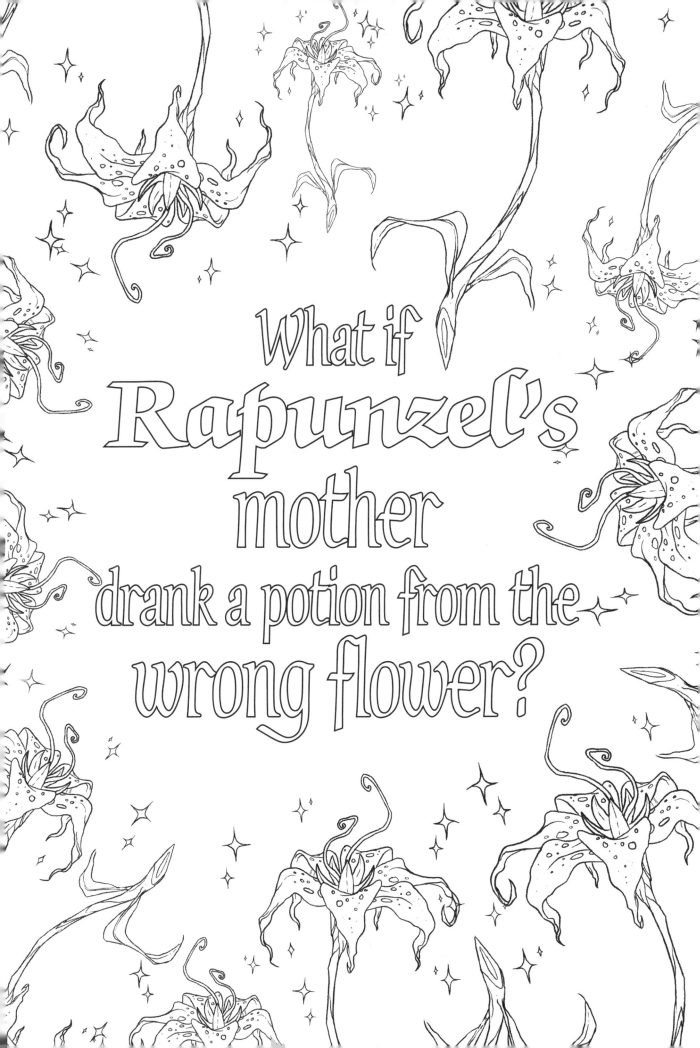

What if **Rapunzel's** mother drank a potion from the wrong flower?

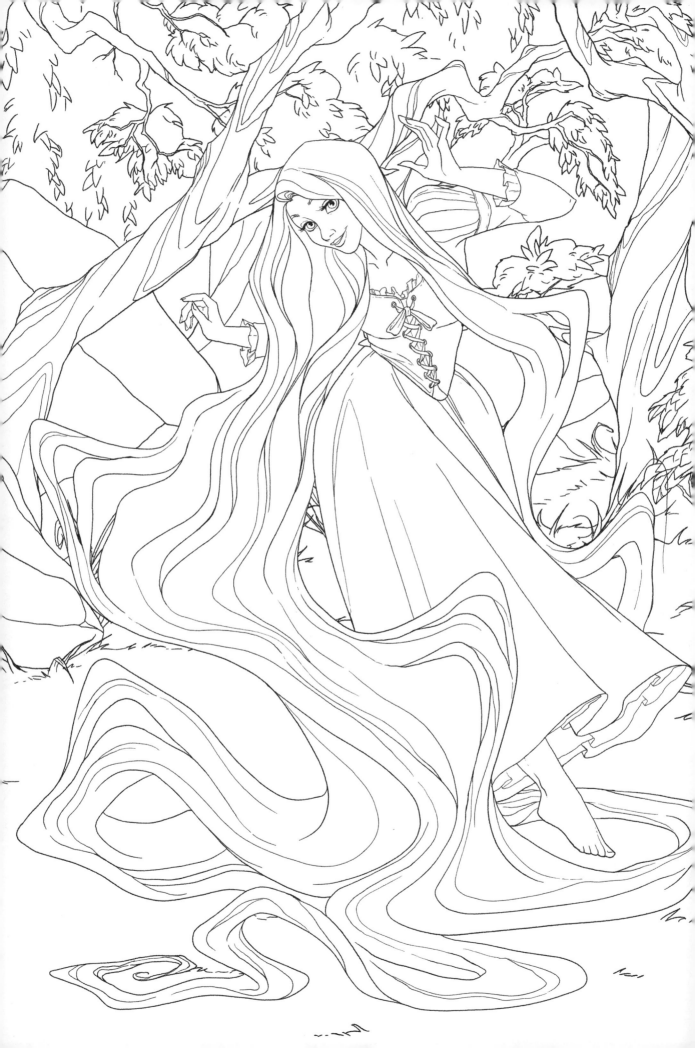

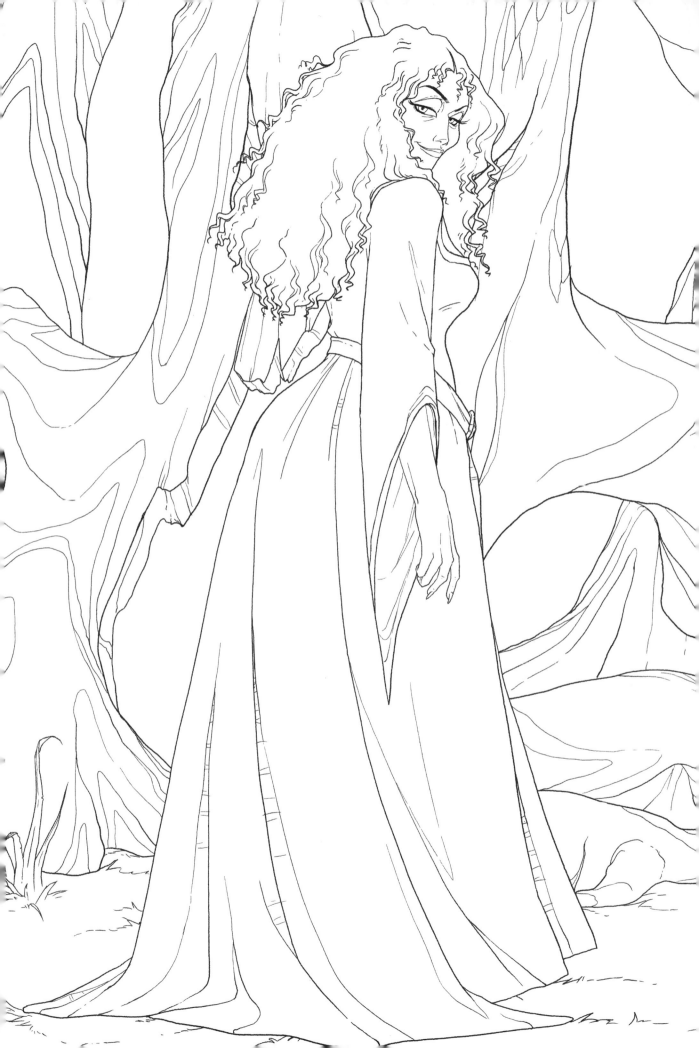

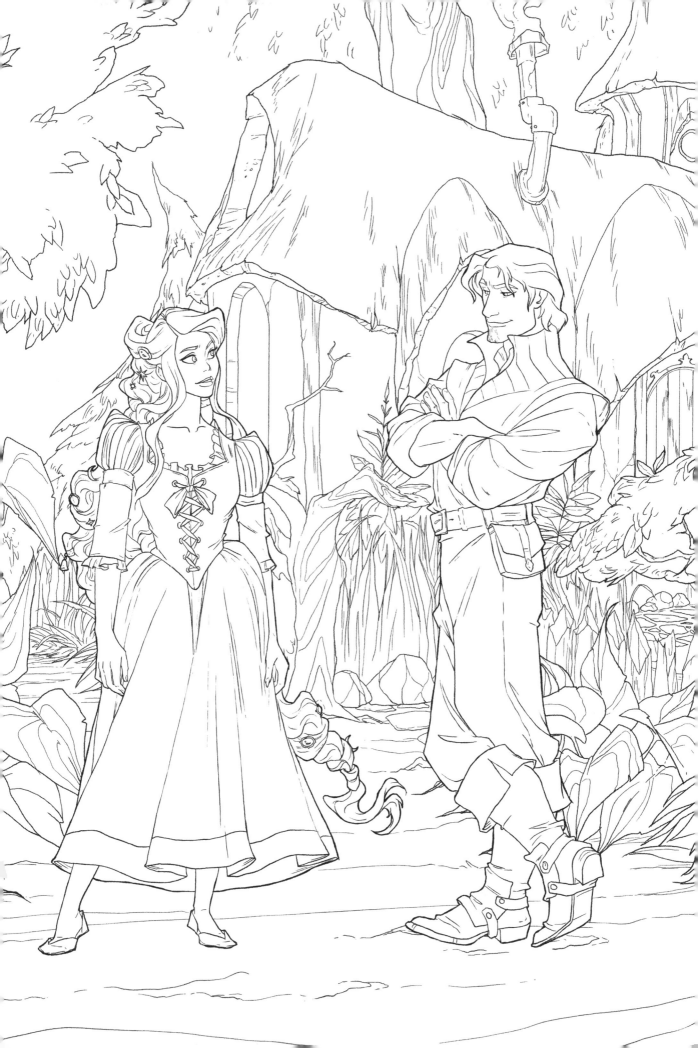

What Once Was Mine

Mother

Knows Best

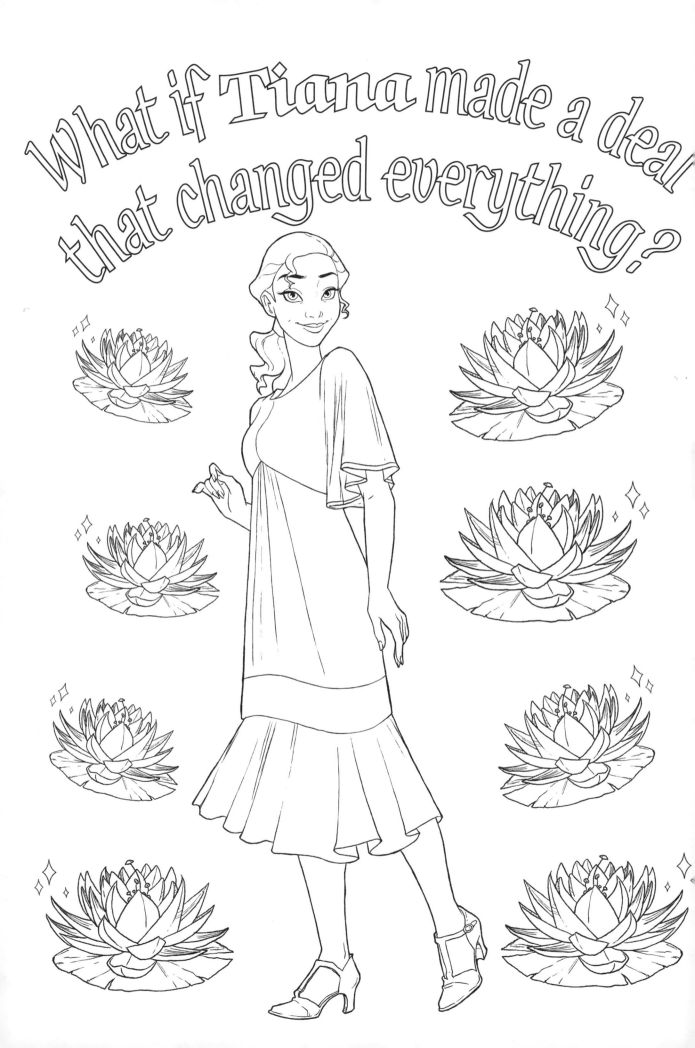

What if Tiana made a deal that changed everything?

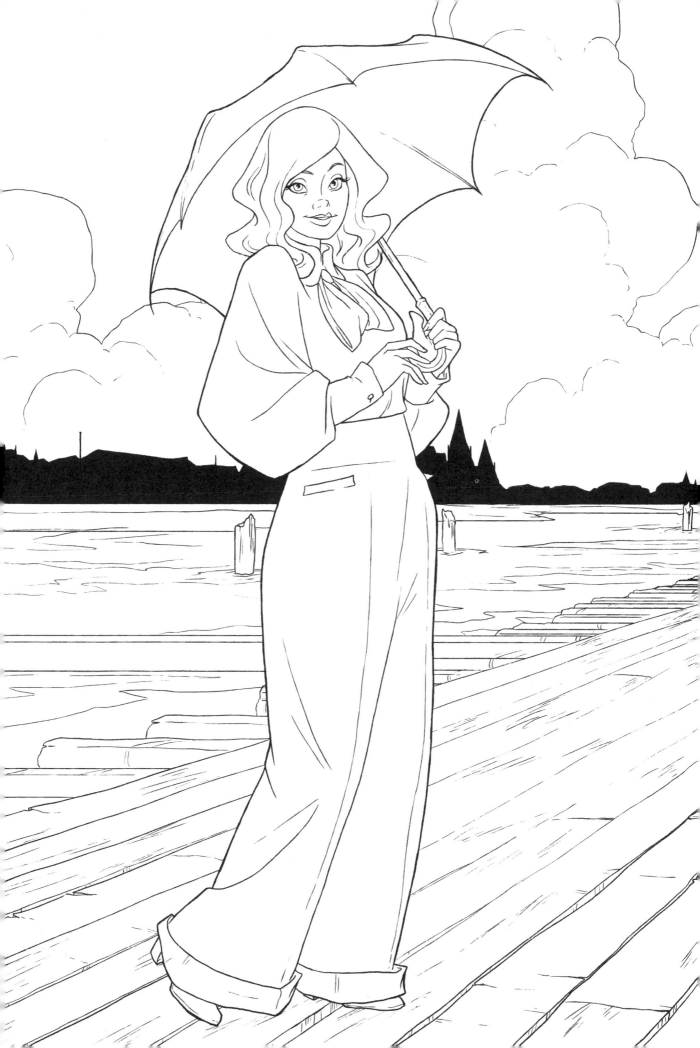

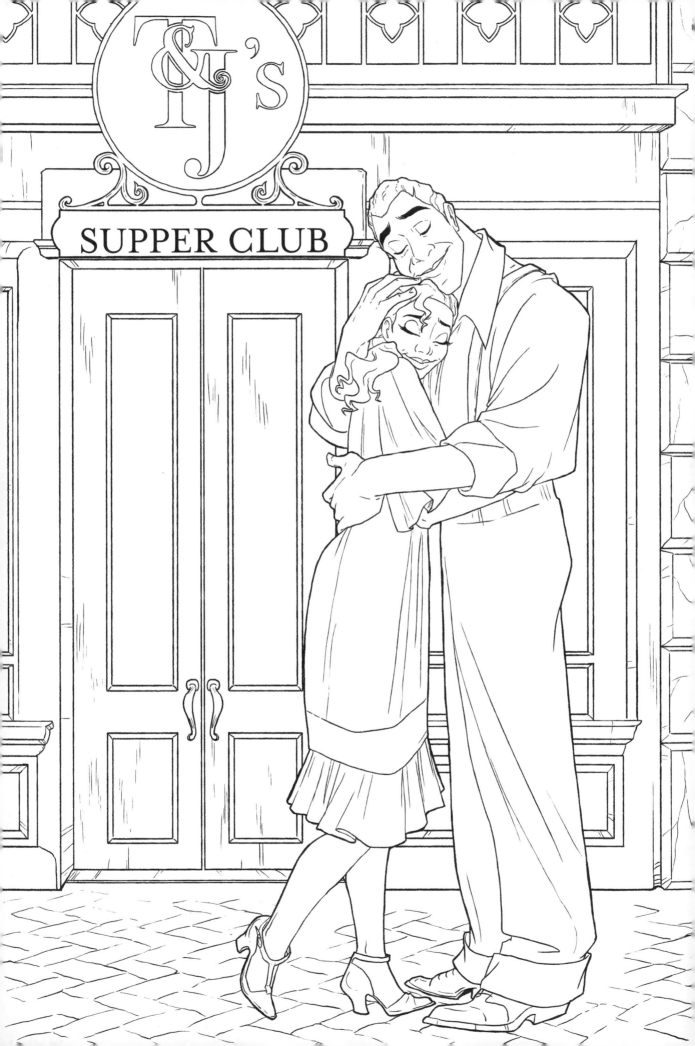

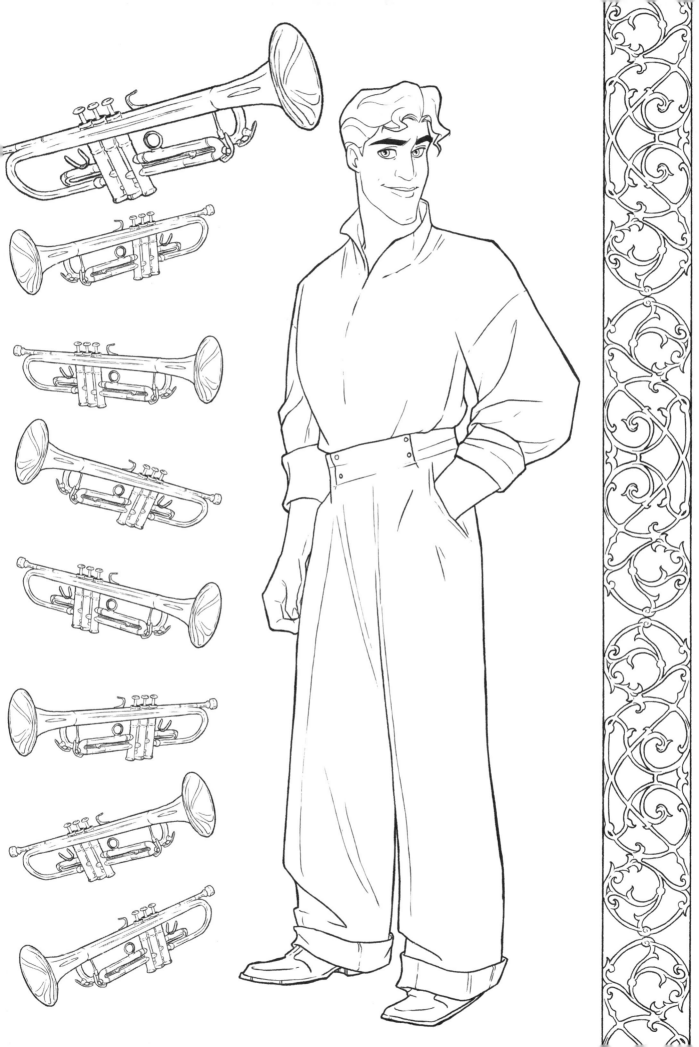

Almost There

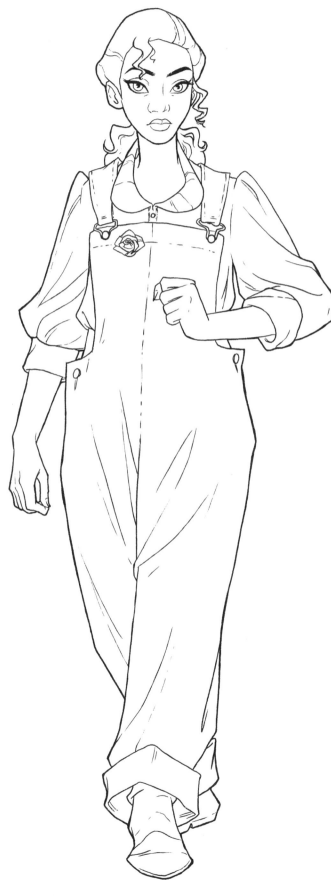

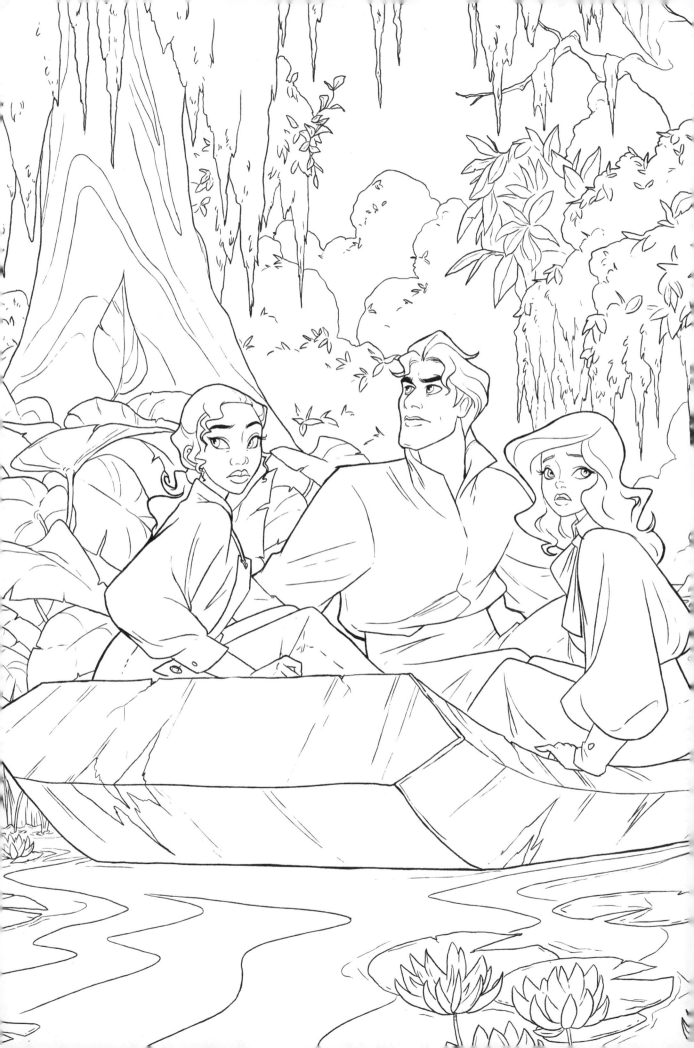

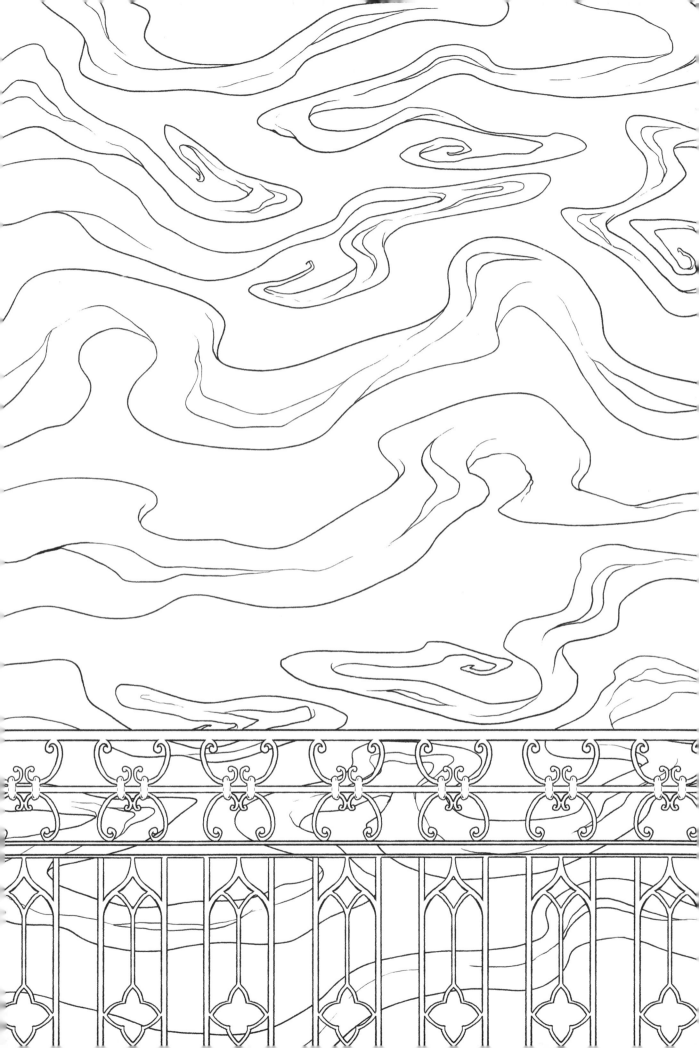

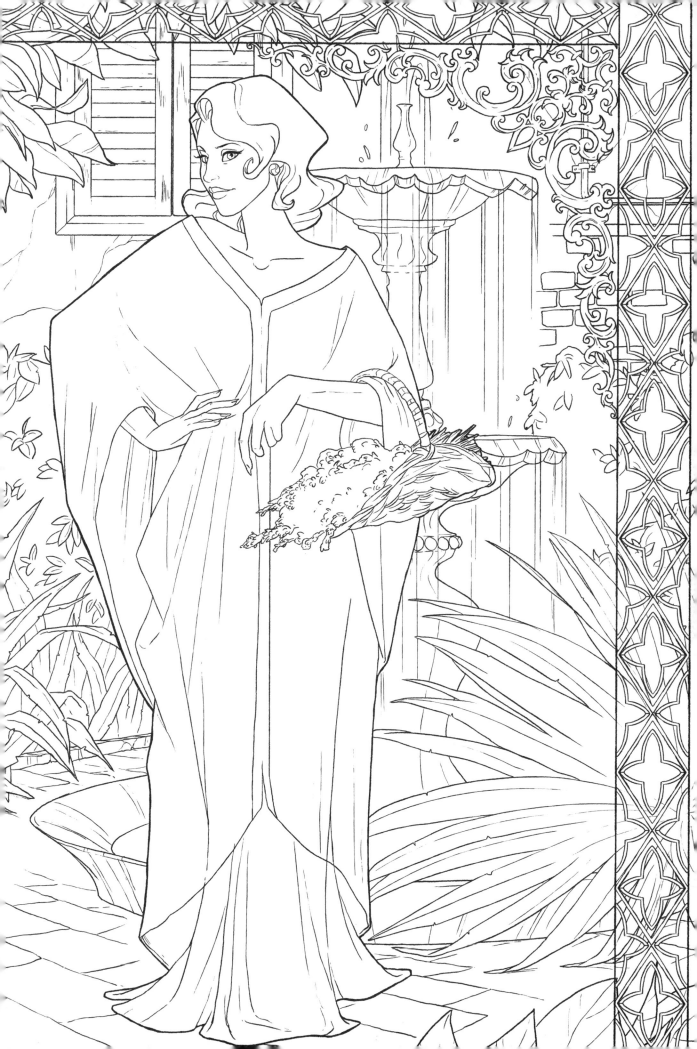

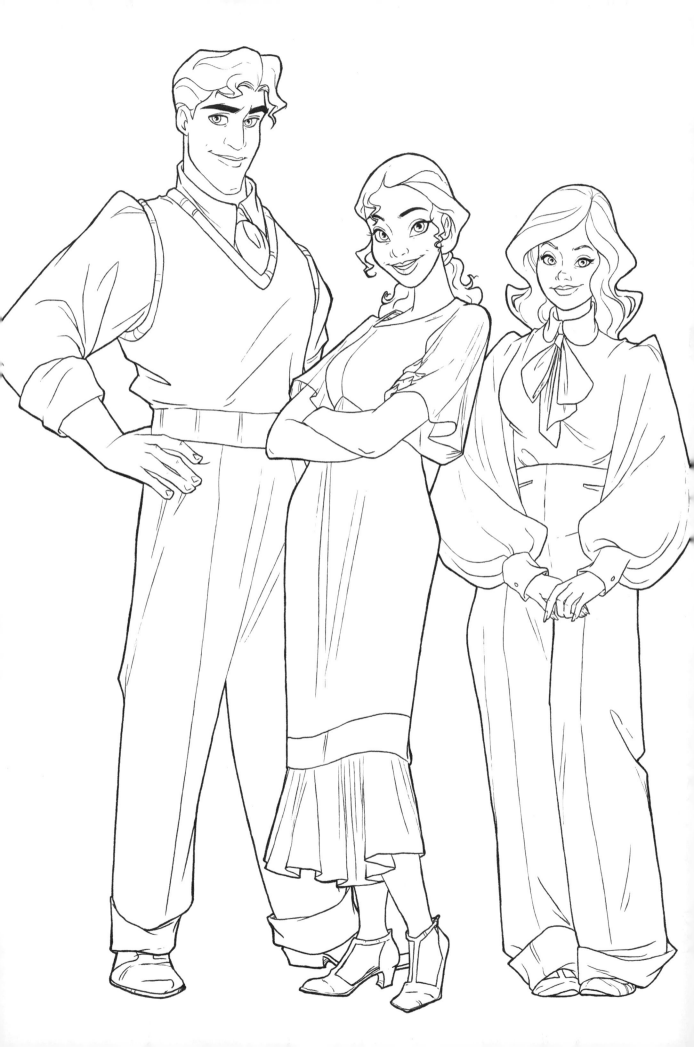

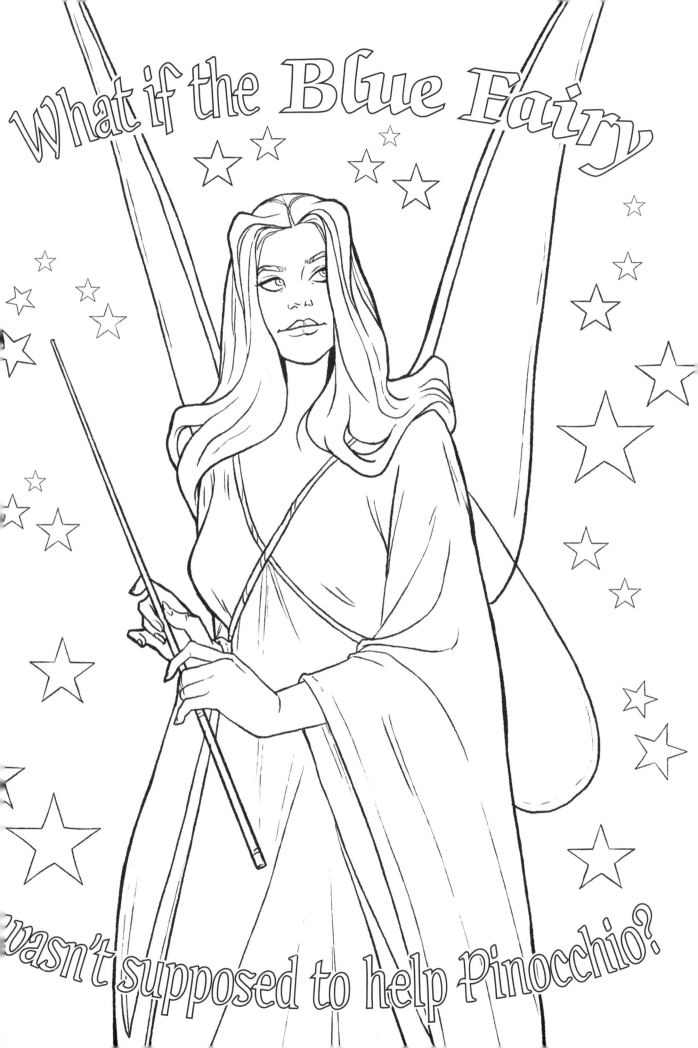

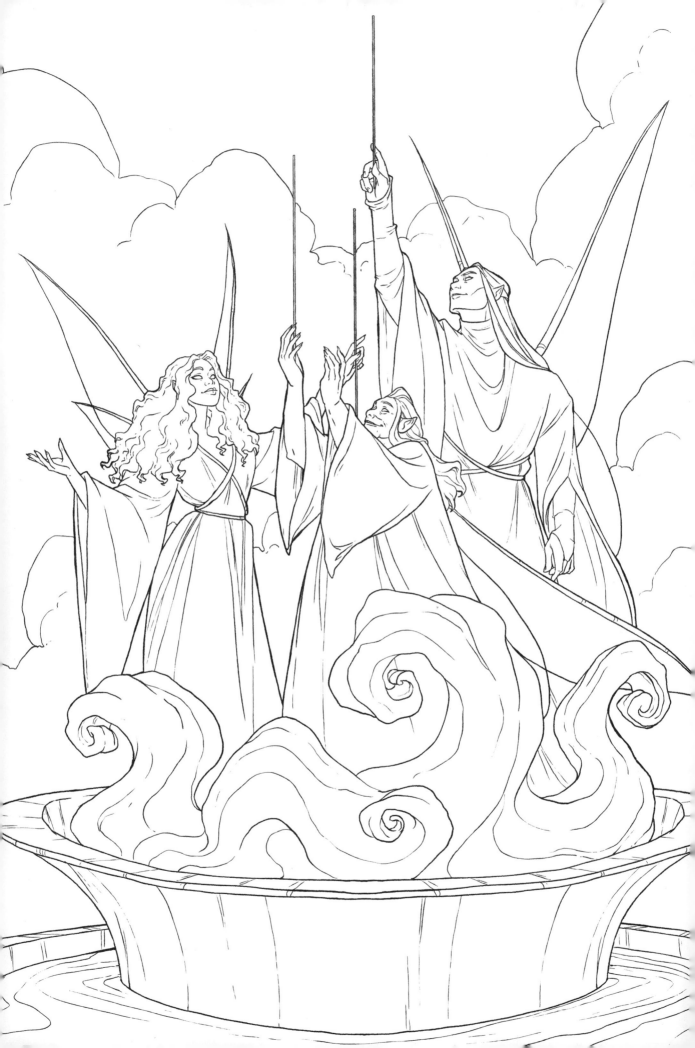

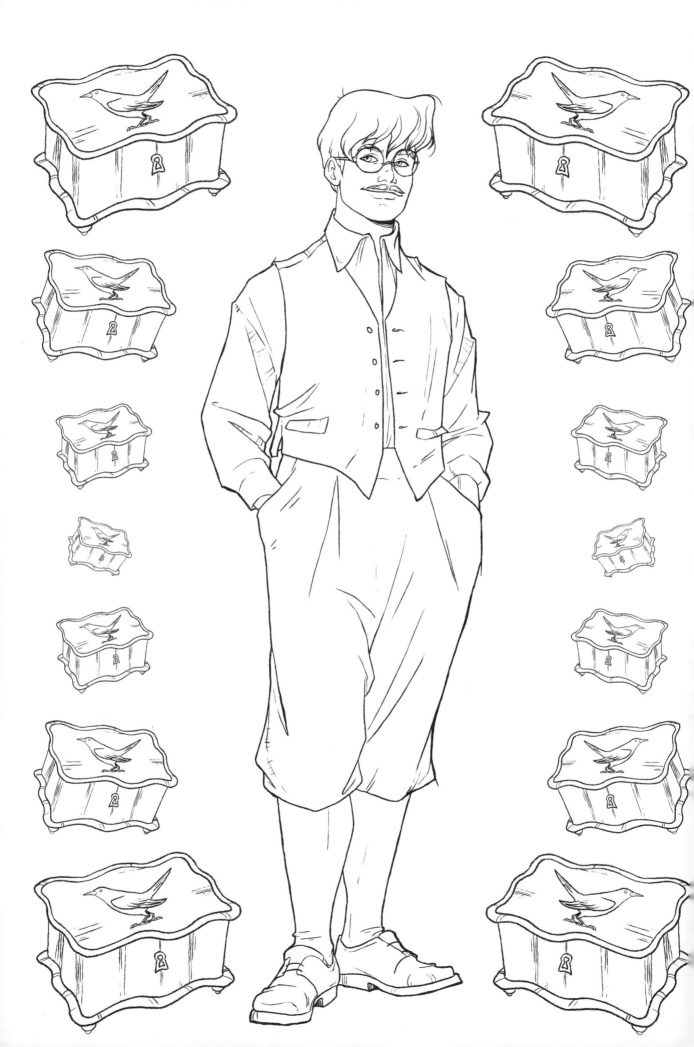

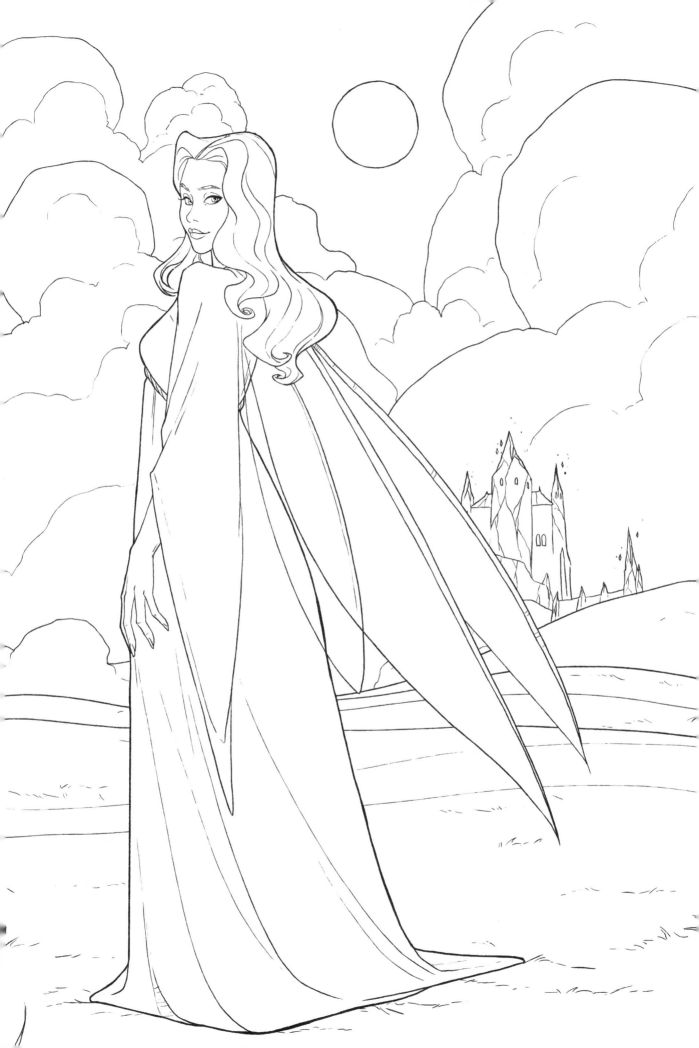

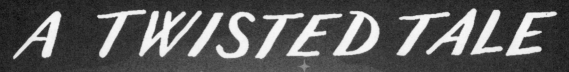

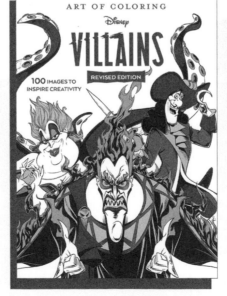